Lost Restaurants

OF

HOUSTON

Lost Restaurants
OF
HOUSTON

PAUL & CHRISTIANE GALVANI

AMERICAN PALATE

Published by American Palate
A Division of The History Press
Charleston, SC
www.historypress.com

First published 2018

ISBN 9781540228949

Library of Congress Control Number: 2017963237

Notice: The information in this book is true and complete to the best of our knowledge. It is offered without guarantee on the part of the authors or The History Press. The authors and The History Press disclaim all liability in connection with the use of this book.

CONTENTS

CONTENTS

ACKNOWLEDGEMENTS

A lot of people helped in the production of this book and we want to thank them here.

Thanks Mike McCorkle, for taking and preserving so many photographs; Carol Look, for keeping alive the memory of Sonny; Conrad Janus, for the record-keeping of Houston restaurants; Chris Tripoli, for providing your professional insights as to why restaurants fail; Ronnie Bermann, for still making the terrific *tarama salada* from Maxim's; Mark Bermann, for sharing so many great stories about your father; Joel Draut at the Houston Metropolitan Research Center, for taking an interest in this project and for finding images for us; Story Sloane III, for preserving so many photographs; Amanda Focke at the Woodson Research Center at Rice University, for pointing out that which was right in front of my eyes; Mark Young, PhD, and Maria Corsi, PhD, for being the keepers of the Hospitality Industry Archives at the Hilton School; Herb Oberman, for going to that estate sale while on your honeymoon and buying that first menu that started it all and helped you amass thirty thousand of them; Ann Criswell, for being the first Houston foodie rock star and for teasing and teaching the taste buds of generations of Houstonians; Nancy Youngblood Counts, for sharing your Youngblood's memorabilia; Debbie Garrett, for keeping the memories of One's A Meal alive; Patty Ramsey, for Valian's memories; and Theresa Matranga Neal, for keeping the box of memories full of photos.

We'll be remembered more for what we destroy than what we create.
—*Chuck Palahniuk,* Invisible Monsters *(1999)*

I knew I was finally a Houstonian when the name Ima Hogg
no longer sounded strange to me.
—*anonymous*

KUDOS HOUSTON!

There is no doubt about it—Houston is a foodie town. The City of Houston Department of Health and Human Services, which oversees the food and beverage industries, tells us that we have 14,129 food establishments in the Houston city limits, of which 6,340 are restaurants. In the event that you decided to eat lunch and dinner at a different restaurant every day, it would take you almost nine years to try them all. A recent garnering of accolades from various national publications confirms that the Houston restaurant scene has made it to national prominence. In 2016, *Travel + Leisure* listed Houston as "One of the Best Cities for Foodies," *U.S. News & World Report* ranked Houston number seven in the "Best Foodie Destinations in the U.S.A." and *GQ* magazine named Houston "America's Next Great Food City" and "The Next Global Food Mecca." John T. Edge, the director of Southern Foodways Alliance, said, "Houston boasts the most dynamic and diverse food and drink scene in the nation." In 2015, the *Washington Post* listed Houston as the no. 5 pick of the "10 Best Food Cities in America," and *Travel & Leisure* ranked Houston no. 1 in "America's Best Cities for Food Snobs." In 2013, *Food & Wine* magazine called Houston "America's Newest Capital of Great Food." When you land at one of the two airports in the city, you are greeted by a sign proclaiming Houston "The Culinary and Cultural Capital of the South." Local chefs have turned into celebrities, and we eagerly await the opening of the latest restaurant. Almost every chain restaurant in the country has an outpost here, and the most recent to add to the vast array of offerings are from newcomers Gus's World Famous Fried

Chicken, based in Memphis, and California-based In-N-Out Burger, both of which are slated to open in 2017–18.

It seems as though Houston has always drawn people to come and live here, and restaurants have followed. This is what one writer said about the city in a *Houston Post* article on April 5, 1910:

> *It would be difficult for me to find a city in the State of Texas in which so many young people are employed in various enterprises as there are in Houston. This is due to the fact that there has been great demand for both male and female help in this section of the country for a number of years past. As a result of the influx of people into the city in response to this call, Houston has become one of the best restaurant towns in the South.*

Eating out in Houston didn't become as popular as it is today until the mid-twentieth century. The immense diversity of ethnic restaurants that defines Houston today was certainly not a feature of Houston in the '50s—although ethnic restaurants have existed almost as long as the city has been around. Aside from some Tex-Mex and Chinese places, there was virtually no other ethnic food available. Before *biryani*, *bahn mi* and bagels, and prior to *pho*, *pancetta* or *pakora*, eating out meant beef and lots of it—even Ding How, a Chinese restaurant popular in the 1960s, featured "K.C. Steaks" along with its traditional food offerings.

In the '50s, coffee was from a percolator, and Houstonians were just discovering wines. There was no craft or artisanal anything: salad was iceberg, dressing was green goddess, national grocery chains did not exist, there were only small local food stores in neighborhoods, there were no food channels on TV. If we didn't recognize it, we didn't eat it. Vegetables were from a can; seafood meant shrimp, crab, oysters and snapper. Neither arugula nor artichokes had made their debut. Food went from being a chore to what it is today: exciting. Food as fuel turned into food as fun. In the early days of Houston, dining out was purely functional, with mainly men eating out at lunch. Social dining, or dining out as entertainment, was not something Houstonians did at that time. By the mid-1950s, people went out to eat to celebrate special family occasions and mark business events—pretty much the same reasons we go out to eat today for what could be considered an important meal. What's different about today is that people go out to eat much more often and not just for important meals. We go out because we can, because eating out in Houston is relatively cheap and the number of different offerings is simply enormous and because

Photo by Paul Galvani.

many people lack the time, cooking skills and desire to prepare a meal from scratch. There is an often-quoted statistic that Houstonians eat out an average of over four times per week, more than the residents of any other U.S. city, according to the Zagat Survey LLC. The first Zagat Guide of Houston restaurants was published in 1989.

HISTORY OF HOUSTON RESTAURANTS

Houston was founded in 1836 by two New York real estate speculators, brothers Augustus Chapman Allen and John Kirby Allen. At the time, the only other settlement nearby was Harrisburg, founded in 1825 by John Harris, also a New York real estate promoter. On January 1, 1837, the city had 12 inhabitants and one log house. By May 1, these numbers had risen to 1,500 people and one hundred houses. In 1839, Houston had 3,000 residents, and in 1846, there were 5,000 people living here. By 1884, the population had increased to 27,000, reaching 71,500 by 1899. Houston's rapid growth pattern was established from very early on. When the city was founded, there were virtually no agricultural products readily available, so a food distribution and preparation system had to be developed to service the needs of this ever-growing population. In the early days, people were self-sufficient hunters and fishermen, and any other food needed to feed the population was brought in by boat. The first steamboat reached Houston in 1838. The *Laura* contained provisions for the settlers, many of whom were living in canvas tents set up on the banks of Buffalo Bayou. Some of the larger tents served as expedient saloons, providing food and drink for travelers and settlers alike. One such tent was called the Round Tent Saloon. In 1840, the Mansion House was the first hotel to be constructed in the city, on Franklin near Main Street. The hotel's Public Room provided meals to guests as well as to the general public. Toward the later decades of the nineteenth century, food became more widely available in saloons and other drinking establishments as well as cafés and restaurants.

The earliest mention of a restaurant we could find in Houston was in the November 16, 1848 issue of the *Democratic Telegraph & Texas Register*, a weekly newspaper. The establishment was called Rockwell & Souters. No address was provided, but the advertisement tells us it was a "well-known restaurant," so no address was necessary. The ad also tells us that the restaurant had undergone some damage, most likely fire-related, since most of the buildings were made of wood: "Their establishment has been thoroughly repaired." The piece goes on to talk about what Rockwell & Souters served: "Their tables are always supplied with the choicest Viands, Meats, &c., served up with neatness and perfect cleanliness…[and the] best oysters from the beds in Galveston Bay." Next, we jump to an 1851 edition of the *Telegraph & Texas Register*, in which there was an advertisement for the Oyster Saloon at the Divan. Again, there is no address given or even a mention of what sort of place Divan was. Then we jump to 1858 and a *Weekly Telegraph* advertisement for the Tremont House and Restaurant on Congress Street, followed by one in 1859, in the *Tri-Weekly Telegraph*, for Our House Restaurant on Congress near Main Street, owned by James Robertson. John Arto's Restaurant, also on Congress Street, was featured in the same issue. In 1860, an editorial in the *Weekly Telegraph* praised Our House and Mr. Robertson in glowing terms and gave us our first indication as to what was popular with diners:

> *He is the very King of caterers…*[and] *no restaurant could be better supplied with delicacies than is his and nothing that a reasonable man could ask for is wanting there.…Fish and oysters, ducks, geese and all other game, turkey, beef, mutton, etc., etc. always crowd the larder. Robertson's Our House is a trump.*

Our House had just moved to this location due to a fire earlier that year, hence the need to let patrons know that the restaurant had reopened. We also learn from an advertisement for Our House in the same edition that it was open from 6:00 a.m. until 11:00 p.m. Since many of the buildings of the time were made of wood, fires were frequent and many businesses destroyed by them. In an earlier edition of the *Weekly Telegraph*, there is mention of a fire that damaged not only Our House but also E. Hudspeth's restaurant and Richard Dowling's Bank of Bacchus, which were housed on the same block of Congress. In addition, damage spread to "several coffee houses, bakeries, hucksters' shops, etc. adjoining and running round on Market square." Two whole blocks of Congress burned to ashes.

The Houston City Directory of 1866 placed T.J. Prindle's Exchange Restaurant on Main Street, and it advertised, "All kinds of game, fish, oysters, &c. At Command." In the same directory, Elsbury & Buckley Confectionary & Restaurant on Congress advertised, "Highest market price will be paid for beef hides." Perkin's Corner, a saloon between Main and Travis, "under the original auspice of Brother Perkins," offered "free lunch every day at half past 10 o'clock." Offering free food in the hopes that customers might imbibe more—something that some bars and restaurants offer during happy hours today—was clearly a device used from the very start of the restaurant trade in Houston.

In the early years of Houston, oysters were a very popular meal, and oyster parlors began to appear. The shellfish were served in many forms: raw, boiled, grilled, roasted, steamed or fried. One place, the Acme Café, even served oysters all day and night. Oysters were purported to have medicinal purposes, but they were not advertised, as one might think, as an aphrodisiac. As it is today, it was common for a business advertised in a newspaper to be described and promoted in a small editorial in a different section of the paper. When Rockwell & Souters took out the ad described earlier, the editorial staff added a paragraph in the same edition:

> *They have constantly on hand a supply of fresh oysters; and we would remind all invalids who are troubled with dispepsy* [sic], *diseases of the lungs, &c. that a small dish of fresh wholesome oysters, taken regularly twice a day, affects these diseases more beneficially than all the quack medicines ever invented.*

In 1866, the Houston Oyster Depot Restaurant and Coffee Saloon opened at 30 Travis Street. It was owned by John H. Lang. This was followed shortly thereafter by Lang's Oyster Parlor, which was established in 1868 at 206–10 Travis Street in the Cotton Exchange Building, the heart of what was then the main commerce area of downtown Houston. It was owned by John H. Lang Jr. and Edward H. Lang. They specialized in Berwick Bay oysters from the lower Atchafalaya River near Morgan City, Louisiana. The venture must have been quite successful; until 1906, the Langs advertised that theirs was "the only oyster parlor in the city." In 1905, they opened a location at 308 Travis, then another on 313 Travis in 1908. At that time, oyster parlors were seasonal, opening only in months with *R*s in the name. Articles in the newspapers talked of the excitement and anticipation of the oyster season opening in September each year, as it closed in May. Competition for the

oyster business started appearing in 1908, with the Gem Oyster Bar, which opened at 908–12 Texas Avenue, as well as Lewis' Oyster Bar at 1013 Preston Street, owned by John Lewis. Also in 1908, the Dudley Bros. Oyster House and Specialty Restaurant opened at 414 Main Street.

References to early restaurants in Houston are scarce. In her book *Houston, The Unknown City*, Marguerite Johnston wrote:

> *In the booming 1870s, Main Street was lined with fancy restaurants serving imported delicacies as well as oysters, shrimp, and fresh fish from the bay. It was also lined with saloons, many with a gambling parlor upstairs.*

Unfortunately, there is no mention of the restaurants' names. The 1884 City Directory lists fourteen restaurants: P. Antonorsi, the St. Charles, G.H. & S.A. Dining Hall, Delmonico's, G. Frederick's, the Cosmopolitan, T.J. Gowan, Mrs. T. Greenough, the Union Depot, Bon Ton, Mrs. H. Ludke, M. Mesinger, W.K. Rice & Co. and George Russell's. Then we jump ahead a few years to the first mention of the Big Casino Restaurant and Saloon at 68 Congress Avenue between Main Street and Travis Street, which was in the Houston City Directory of 1887–88. The Big Casino was owned by Charles A. Dumler. By 1895, it had moved to 908 Congress Avenue and changed ownership to Emile Clede and Henry Koenig. By 1902, the concept of meal deliveries had taken hold, and the Big Casino Restaurant and Saloon served family meals "at your private home for 25 cents and upwards." Then came Genora's White Kitchen at 1007–9 Main Street, which was established in 1890 by Michael and Lawrence J. Genora. The Genoras were born in Sicily and immigrated to the United States. They landed in New Orleans, then moved to Chicago, where Mike gained his first knowledge of the restaurant business. The family subsequently moved to Galveston, then to Houston, where they started out by selling produce in the Fifth Ward, which is where their first restaurant was located. By 1905, the restaurant had moved to 412 Main Street and after a fire destroyed that building in 1914, the Genoras opened a second location at 614–16 Main Street in 1915. This location suffered $10,000 in damage in a fire on December 19, 1923. They then moved to 914 Capitol Avenue until 1928, when they opened "the largest and finest location" at 2007 Main Street. An ad in the *Rice Thresher* shows the Genoras were still in operation in 1932. The ad claimed that the White Kitchen was "Famed for High Grade Foods and Quick Service." Jim Wing's Restaurant opened at 805 Congress Avenue in 1894. The Princeton Café opened in 1895 at 1012 Texas Avenue, "under the Y.M.C.A. rooms."

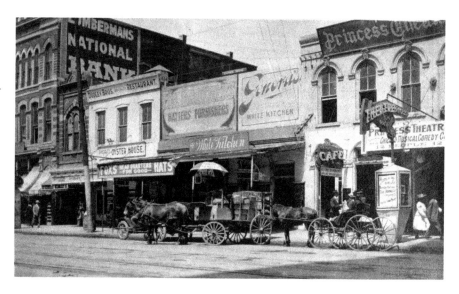

Genora's White Kitchen was located at 412 Main Street from 1905 to 1914. *Houston Chronicle archives.*

Pizzini's French Restaurant opened in the same year at 513–15 Main Street. By 1902, Broetzmann's Oyster and Chile Parlor was operating at 513 Travis Street. The earliest Mexican restaurant to open in Houston dates to 1906 at 807 Fannin Street. It went by the accurate, if not creative, name of the Original Mexican Restaurant and was owned by George Caldwell of San Antonio. In *Pen and Sunlight Sketches of Greater Houston*, published in 1913, a description of the restaurant reads as follows:

> *Of all the first class restaurants of Houston none is better known nor more widely patronized than the Original Mexican Restaurant, which is located at 807 Fannin Street, an ideal location for a business of this kind. The place is handsomely furnished throughout in true Mexican style, and the very best of Mexican dishes cooked by native Mexican cooks, are served. While the business has been established only about five years, it has during that time gained fame throughout the state, and is one of the most popular resorts in Houston, being patronized by a large circle of its best citizens. Mr. G.E. Caldwell, the proprietor of the restaurant, is a native of Texas and a former citizen of San Antonio, where he spent the larger part of his life, and where he also learned the ways of the Mexicans and gained his experience in preparing the delicious Mexican dishes. Regular meals are served at 35 cents, all of Mexican dishes,*

while short orders are to be had at any time between noon and midnight.
Mr. Caldwell makes a specialty of catering to parties, and does a big
business in this line.

The Original Mexican Restaurant later moved to 608 Travis Street and
then to 410 Fannin Street around 1918. By 1922, it had moved again,
to 1109 Main Street. There was also a location on Galveston Island that
opened in 1908.

In 1904, Gustav F. Sauter opened a café on the corner of Travis Street
and Preston Street. It had separate ladies' and men's dining rooms. The
café boasted a "Gentlemen's Restaurant and Bar" downstairs, and women
were welcomed in the "Ladies' Dining Parlor upstairs." Next door was
the G.F. Sauter Delicatessen. An ad in the January 16, 1910 edition of
the *Houston Daily Post* claimed it was "The Oldest and Most Popular
Restaurant in the City." Sauter opened the Drummer's Exchange in 1896
on the same corner where you could get "Noonday lunch from 12 to 3 p.m.
consisting of Soup, Fish, Entrees, Roast, Vegetables. Prices Moderate." As
early as 1891, his establishment was known as G.F. Sauter, Wholesale and
Retail Liquor Dealer. Sauter catered to Houston's elite, and the restaurant
was famous for its fine steaks and liquor. The IWW French and Italian
Restaurant opened in 1906 at 703 Preston, and Rectors Café opened in
1910 at 410 Main.

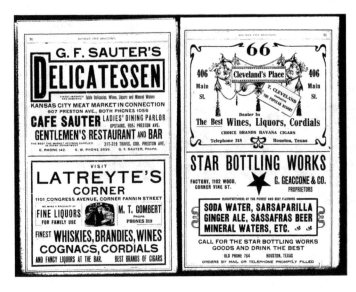

Advertisement
for G.F. Sauter's
Delicatessen.
Houston City
Directory, 1908.

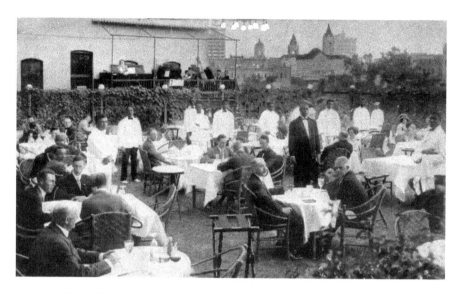

Al Fresco dining, Hotel Brazos Court, Houston, Texas. *Authors' collection.*

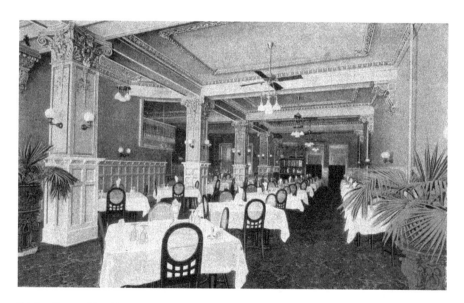

Dining Room. Hotel Brazos, Houston, Texas. *Authors' collection.*

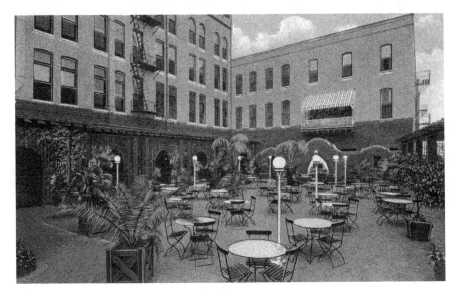

Brazos Court. Finest Out of Doors Dining Place in the World. *Authors' collection.*

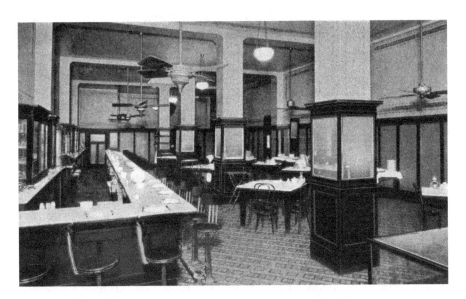

Grill Room. Hotel Brazos, Houston, Texas. *Authors' collection.*

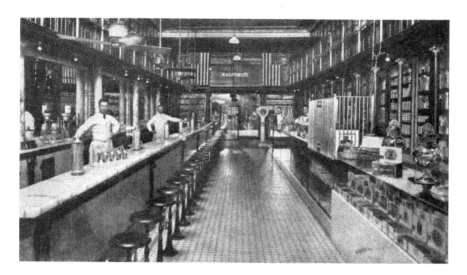

Radford's—Houston, Texas. *Authors' collection.*

The American Red Cross was founded in Washington, D.C., in 1881. The Houston chapter was established in 1916. Volunteers immediately started fundraising in the city and, in 1918, published a list of businesses that made financial contributions. That list included a number of restaurants: Van Nuys's Restaurant, Houston Café, Milwaukee Delicatessen, Elite Café, Manhattan Café, Colby's Restaurant, Ellington Café, Magnolia Café, Acme Restaurant, Frank Canatella's, Public Café, Milam Café, Oriental Café, Munn's Lunch Room, Levy's Tea Room, Presto Café, Sazzarac Café, Plaza Café, Thomson's Restaurant, Pekin Café, Blue Front Restaurant, Albritton's Café, Wo Lee, H. Blumberg, Jim Wing, Lincoln Café, Wallace Café, People's Café, Quick Lunch Counter, Blair's Restaurant, Fred Harvey's Restaurant and Benart Café.

Any discussion about restaurants must also include an understanding of Prohibition, which lasted from 1920 until 1933. Texans repealed the law in the same year, but it did not take effect because of a 1919 state prohibition amendment to the Texas state constitution. Prohibition was finally repealed in Texas in 1935. Liquor could only be sold by the bottle until 1961, when the Liquor Control Board (now the Texas Alcohol Beverage Commission) began licensing private clubs. Club membership allowed members to keep a bottle at the club and drink whenever they wanted to. All they had to do was pay for a setup and service. Restaurants and hotels soon began to offer temporary (i.e., one day) club memberships allowing their members

the same privilege. Liquor by the drink did not become law until April 1971. However, portions of the Heights neighborhood remained dry until November 2017. The Heights was a city of its own, founded in 1891 and incorporated in 1896. It was annexed by Houston in 1912. In 1937, the Texas Supreme Court ruled that the Heights was to remain dry until the residents who lived within the original boundaries voted otherwise. They finally did so in late 2017.

EARLY EATING ESTABLISHMENTS

Many early restaurants in Houston were to be found in hotels and boarding houses, which makes sense, as travelers visiting Houston likely wanted meals once they arrived. Hotels like the Mansion House (1840); Capitol Hotel (1857); the Auditorium Hotel; the Grand Central Hotel (1880s), which became the Hotel Brazos; the Hotel Bristol (1904); the Hotel Macatee (1906); the Savoy Hotel (1906); the Binz Hotel (1908); the Hotel Bender (1910), which became the San Jacinto Hotel in 1931; the Rice Hotel (1911); the Milby Hotel (1912); the Hotel Cotton (1913), which became the Hotel Montague in the 1950s; the De George Hotel (1914), which became the King George Hotel in 1956; the Sam Houston Hotel (1924), which turned into the Alden Hotel; the William Penn Hotel (1925); the Ben Milam Hotel (1926); the Hotel Plaza (1926); the Warwick (1926), which turned into the Hotel ZaZa in 2007; the Auditorium Hotel (1926), which turned into the Lancaster Hotel in 1982; the Houston Heights Hotel; the Lamar Hotel (1927); the Texas State Hotel (1929), which turned into the Club Quarters; the William Perry Hotel; the Tennyson Hotel; the Shamrock Hotel (1949), which became the Shamrock Hilton in 1955; and the Argyle Hotel, among others, all had restaurants or at least coffee shops. Hotel dining rooms were large and luxuriously decorated, and many had dance floors.

The Hotel Brazos, originally called the Grand Central Hotel in the 1880s, was considered one of the finest hotels in the city. It was located opposite the Southern Pacific Railroad station between Washington Avenue and Buffalo

Left: The Rice Hotel. *Courtesy of the Trustees of the Boston Public Library*.

Below: Main Dining Room, the Rice Hotel. *Authors' collection*.

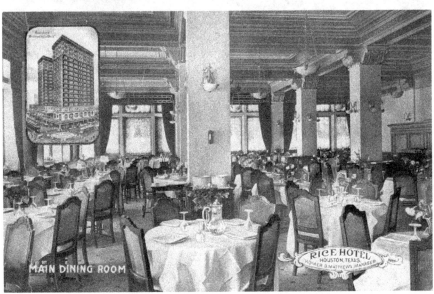

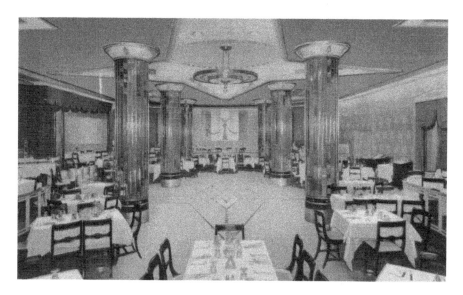

The Empire Room, Rice Hotel. The back reads, "The luxurious new Empire Room of the Rice Hotel is the South's finest dine and dance rendezvous featuring America's outstanding dance orchestras and excellent cuisine." *Authors' collection.*

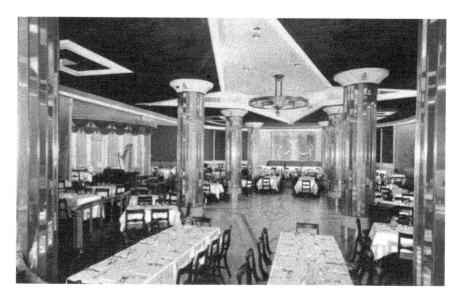

The Empire Room, Rice Hotel. The back reads, "The Empire Room, Rice Hotel, Houston, Texas. We're having a delightful time dining and dancing in the beautiful Empire Room." *Authors' collection.*

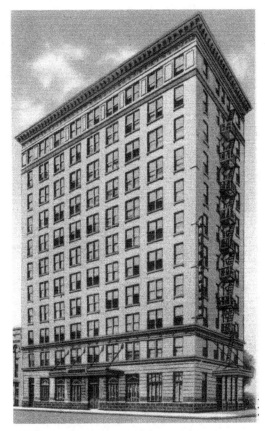

Left: Hotel Colton. *Courtesy of the Trustees of the Boston Public Library.*

Below: Ben Milam Hotel Dining Room and Coffee Shop. *Authors' collection.*

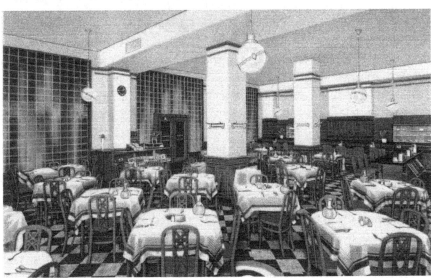

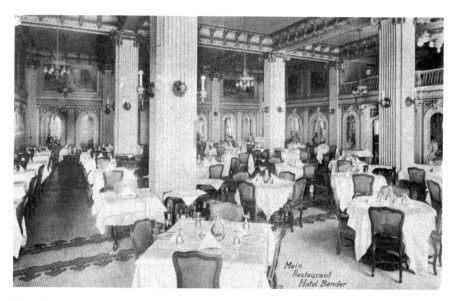

Main Restaurant, Hotel Bender, circa 1912. *Authors' collection.*

Bayou. It had 220 rooms, many with private baths. It also boasted a French chef as well as an outdoor dining area with musical entertainment from an orchestra. Sarah Bernhardt and Presidents Taft and Theodore Roosevelt stayed here. Torn down in the 1930s, the Brazos stood on the area that used to be part of the downtown post office.

One interesting side note about the Lamar Hotel, which was one of Houston's most prominent hotels in the 1930s, is that in addition to the fact that it was owned by Jesse H. Jones, the restaurant it housed was called the Black Mammy Cafeteria—a name that would cause public outrage today. Jones was a politician and entrepreneur and owned the *Houston Chronicle* and the Rice Hotel. He became president of the National Bank of Commerce and established the Houston Endowment. The Lamar Hotel was also famous for the Suite 8F Group, which was also known as the Lamar 8F Group or the Secret Government of Texas, of which Jones was an active participant. The group was composed of wealthy, politically active people who met in Suite 8F of the hotel in order to raise money to elect influential politicians who supported their political views. The room was permanently rented and paid for by members of this group from the 1930s to the 1960s. The group was made up of only nine people, a who's who of Houston's powerful elites: Herman Brown, George Brown, Jesse Jones, Judge Jim Elkins, Jim

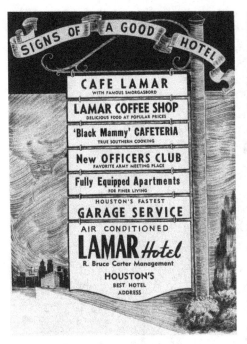

Left: June 1941 issue of *Texas Hotel Review* featuring the Black Mammy Cafeteria. *Hospitality Industry Archives, Hilton College, University of Houston.*

Right: The Lamar Hotel. *Courtesy of the Trustees of the Boston Public Library.*

Abercrombie, William P. Hobby, Gus Wortham, Lamar Fleming and the only woman of the group, Oveta Culp Hobby.

In addition to hotels, department stores also had restaurants and tearooms. This made sense in that it prolonged customers' visit to the store because they did not need to leave in order to eat. More time in the store meant more opportunities to spend money there. Plus, stores attracted people to town from the country, so the crowds had to be fed. Joske's (Camellia Room, Bamboo Room), Sakowitz (Sky Terrace), Foley's (Azalea Terrace), Battelstein's (Elusive Butterfly Tea Room), Marshall Fields (The Restaurant) and Neiman Marcus (Mariposa Lunchroom) all had restaurants, tearooms or lunch counters. It also made sense that supermarkets like Weingarten's, Henke & Pillot had lunch counters because they already had access to the ingredients to prepare a meal.

Drugstores and pharmacies such as Mading's Drug Store, the Radford Drug Company and Yale Pharmacy had lunch counters. The Radford Drug

Texas State Hotel. *Courtesy of the Trustees of the Boston Public Library.*

Company opened at 319 Main in 1917 and offered a full soda fountain. Walgreen's at the Sharpstown Mall and Woolworth's downtown and at the Northwest Mall also had lunch counters. Then there were the private clubs like the Petroleum Club—which occupied the penthouse wing of the Rice Hotel—the Thalian Club, the Houston Club, the Houston Country Club, the River Oaks Country Club and the Insurance Club.

HOUSTON HAD ETHNIC RESTAURANTS BACK IN THE DAY

On the very early days of Houston, tamale vendors roamed the streets of downtown, and chile stands could be found around Market Square. They served Anglo patrons and well as Tejanos (Texas Mexicans). In the Houston City Directory of 1899, there were a total of forty-eight restaurants listed. Of those, more than one-third were ethnic. At that time, Houston had nine Chinese restaurants, six chile stands and two French restaurants, setting the stage for the vast diversity of cuisines we enjoy today.

Following the Battle of San Jacinto in 1836, Texians (Anglo Texans) used Mexican prisoners and enslaved Africans to clean up the swampland on which Houston was to be built. Once that task was completed, the Mexicans were sent home, but some remained. In 1900, the Mexican population of Houston numbered 500, and shortly thereafter, the number doubled to 1,000. It had doubled again to 2,000 by 1910 and ballooned to 14,500 by the start of the Great Depression in the 1930s. It took another fifty years for the Mexican population in Houston to reach 500,000, and by 2010, it had reached 1.6 million, including Mexicans, Mexican Americans and Tejanos.

The first mention of a Mexican restaurant was the Original Mexican Restaurant at 807 Fannin Street, which was opened in 1907 by George Caldwell, an Anglo from San Antonio. The next Mexican restaurant, owned by a Mexican, was the Eciquia Castro Café, which opened in 1915 at 613 San Felipe Avenue. Then came Melesio Gomez, who opened La Consentida at 1708 Washington Avenue in 1932. In those days, these

Mexican-owned restaurants did more than just serve food. They served as a sort of community center, providing social and cultural support both to the Mexicans who were already here and to those who had just arrived. Local clubs and societies often met at these restaurants because they felt safe surrounded by their countrymen. In some cases, the restaurants became a hub of civic and political activity as well.

In an article he wrote for *Sugar & Rice* magazine titled "The History of Houston Food," executive director David Leftwich discusses some of the other ethnic restaurants in Houston:

> *Tsunekichi Okasaki, who emigrated from the Okayama Prefecture in 1888, opened, in the late 1890s, Houston's first Japanese restaurant, which served both American-style meals and some Japanese food. His restaurant employed and also catered to the newly arrived Japanese. To make it easier for English speakers and to appeal to his Anglo clientele, like those working at the Harris County Courthouse across from his location at 1111 Congress Avenue, Okasaki went by Tom Brown Okasaki (or sometimes just by T.B. Okasaki) and initially called his business Tom Brown's Japanese Restaurant....[S]ometime between 1907 and 1911, Okasaki opened a second location at 407 Travis Street, catty-corner to Market Square, and changed the name to the even more "American" sounding Eagle Café.*

In 1888, when Okasaki arrived in Houston, he was one of the first three Japanese immigrants. He became known for selling a substantial meal for $0.10 to $0.25 at his restaurant. An advertisement for the Japanese Restaurant shows how good a promoter he was; it offered meal subscriptions, thus ensuring a loyal following. He sold a $5.50 meal subscription discounted to $5.00, which surely must have been one of the first promotional offers in this line of trade. An announcement in the newspapers in 1913 tells us of the expansion of Okasaki's restaurants on the corner of Travis and Prairie Streets. It was originally to be called the Chop Suey Café. Sometime before opening, however, the name changed to Eagle Café and Chop Suey Parlor. The Eagle Café had entertainment, with a daily orchestra, cabaret singers and an outdoor veranda. A menu from 1915 for the Sunday dinner special offered upscale American cuisine. There was no mention of any Japanese or Chinese dishes: "Canapes of Caviar, Crabmeat Cocktail, Consommé, Chicken Soup, Filet of Gulf Trout, Squab Chicken à la Maryland, Roast Leg of Veal with Asparagus Tips." The café also served gumbo.

By 1910, Texas had 350 Japanese settlers. By 1920, there were almost 450, many coming by way of Mexico—where they had worked in the mines or railroads—and others from San Francisco, after the 1906 earthquake.

In the same article, Leftwich also chronicles the first Chinese restaurants in Houston:

> *Despite the few Chinese living in Houston at that time, there were, in 1902, several Chinese businesses in the Bayou City, including five restaurants: Little Gem at 405 Travis Street, owned by C.G. Hong (who in 1899 may have been a cook at another Chinese restaurant at 1113 Congress, next to Tom Brown's); Sam Wah owned a restaurant at 418 Travis Street; Tom Lee & Company at 407 Travis Street; Home Star at 408 Milam Street; and Jim Wing & Company's Star Restaurant at 805 Congress Avenue.*

The Chinese first came here with the railroad construction that started in the mid-1850s. In their 1982 book *Chinese in Houston*, Fred Von der Mehden and Edward Chen noted that in the early days, the Chinese were something of a curiosity: "In 1870, crowds of curious Houstonians gathered to see the arrival of 260 Chinese laborers who were traveling through the city on their way to work on the railroads."

They were contract laborers brought here from California, and very few of them stayed in Houston. The 1880 census reported 7 Chinese residents in Houston. At the end of the 1930s, there were still only 50 Chinese people living here, while the 1940 census showed 121 Chinese. This was due mainly to the strict enforcement of immigration laws. The number of Chinese grew to 1,000 in 1955, then 10,000 in 1976.

HOUSTON INTEGRATES

No discussion of restaurants in Houston would be complete without remembering the history of segregation. In his book *No Color Is My Kind,* Thomas Cole describes how segregation was tested at Houston lunch counters and eventually overturned:

> *The first sit-in against segregation west of the Mississippi occurred on Friday, March 4, 1960 at the Weingarten's Supermarket lunch counter on Almeda Road and Wheeler Avenue. Seventeen African-American students from Texas Southern University sat at the lunch counter and asked to be served. White customers left without finishing their meals. The store manager called his headquarters for instructions. A few minutes later he returned to the lunch counter with two signs which read "Lunch Counter Closed." The following day, a group of TSU students sat at the lunch counter of Mading's Drug Store. They were met with a sign saying "Fountain Closed." By Monday, the students had formed a group called the Student Protest Movement (SPM). Their next target, the Henke & Pillot Supermarket on Crawford Street. Here, too, they were met with the closure of the lunch counter. Merchants soon realized that this situation was costing them money. The next week, the students moved into the downtown area and began sit-ins at downtown stores on Main Street. Foley's, Grant's, Walgreen's and Kress stores were all targeted. Rather than call the police, the lunch counter operators shut down their establishments.*

It wasn't long before the senior vice president of advertising and publicity for Foley's Department Store, Bob Dundas, decided to work behind the scenes with business leaders to find a solution. The last week of August, he got the business community to agree to integrate seventy lunch counters in department stores, drugstores and supermarkets, all over the city. He was also, somewhat miraculously, successful in ensuring that there would be no press coverage of this momentous event. With commitments from the local newspapers, radio stations and TV stations in town, the complete news blackout meant that Texans in every other city in the state knew that Houston had integrated while Houstonians did not. It was deemed that the suppression of news coverage was necessary to accomplish integration without violence. Silence and solidarity seem to have secured desegregation. Ultimately, the desegregation of Houston came down to one thing: the business community realizing that it was good for business.

African Americans were not the only group discriminated against. In the case of Foley's, women were not allowed to dine in the Men's Grill on the second floor of the downtown store. An early advertisement for the Men's Grill announced this was the place "Where menus catered to he-man appetites." In his Images of America series book *Foley's*, Lasker Meyer described the situation thus:

> *When Foley's downtown store was built (in 1947), it had a lunch counter, a full-service tearoom and the Men's Grill on the second floor, located behind the men's clothing department. When women's groups all over the country began demanding equal rights, the Houston group decided that the Men's Grill should be integrated. Small groups with signs began marching through the grill for days, demanding equal service. Foley's gave in, and it was then called "the Grill."*

A DRIVE DOWN MAIN STREET
IN THE 1960s

Today, Westheimer Road is regarded as restaurant row, since it houses more restaurants than any other street in Houston. It stretches nineteen miles from Bagby Street in the downtown area to the Westpark Tollway near George Bush Park. During the 1950s and 1960s, however, Main Street must surely have been considered Houston's original restaurant row. Here are some of the many restaurants that have called Main Street home over the years. As orienting points, the 1000 block of Main Street is at the intersection of McKinney Street downtown, the 6000 block at the intersection with Sunset Boulevard near Rice Village and the 10000 block just south of the South Loop 610.

11321 Elliott's Steaks
10200 Angelo's Fisherman's Wharf
9810 Look's Sirloin Inn
9530 Chin's Poly Asian
9350 John's of Houston
9200 Gaido's Seafood, which became Christie's Restaurant
9047 One's-a-Meal Sandwich Shop
8506 Lott's Grill, which became Captain Benny's
8418 Roland Busch's Seafood & Lobster House
8111 Antone's Import Co.
8101 Prince's Drive-In, which became Two Pesos
8100 Lee's Den

8001 Stuart's Club Grill
7900 Kaphan's
7525 Jamie's Restaurant, which became La Hacienda
7325 The Stables Steakhouse
7315 The Red Lion
7001 Pier 21
6935 Valian's
6900 Trader Vic's (Shamrock Hilton)
6800 Ding How
6703 Christie's Seafood Restaurant
6638 Ship Ahoy, which became Cathay House
6601 Mading's
6545 Ye Old College Inn
6515 Bill Williams Chicken House
6441 Youngblood's Chicken
6415 Leslie's Fried Chicken/The Chicken Shack
4916 Weldon Cafeteria
3512 Kelley's Steakhouse
2414 Simpson's Dining Car 2
1415 Simpson's Dining Car 1
1007 Ship Ahoy
1000 Block One's a Meal Sandwich Shop

In the 1960s, Main Street and the area near the Astrodome were extremely popular because of all the people coming to visit the newly built Astrodome and Astroworld. The Astrodome, opened in 1965, was called the Harris County Domed Stadium and, as everyone from Houston knows, nicknamed the "Eighth Wonder of the World." The Astrodome closed in 2002 but remains standing while the city figures out what to do with it. Astroworld opened in 1968. It was part of the Astrodomain, the brainchild of Judge Roy Hofheinz, mayor of Houston from 1953 to 1955. It was sold to the Six Flags Corporation in 1975 and shut down its rides in 2005, when it was demolished. Construction on Loop 610 began in 1950 and was completed in 1973.

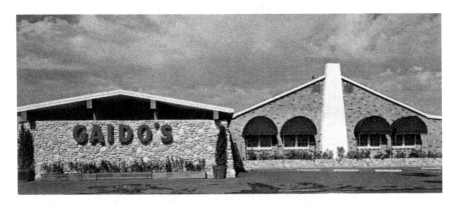

Gaido's. *Authors' collection.*

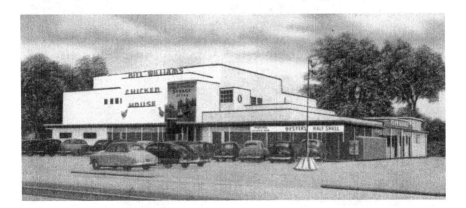

Bill Williams Chicken House. *Courtesy of the Trustees of the Boston Public Library.*

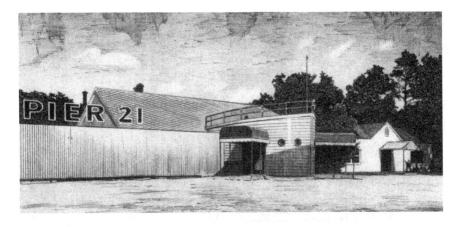

Pier 21. Houston, Texas. World's Finest Seafood. *Authors' collection.*

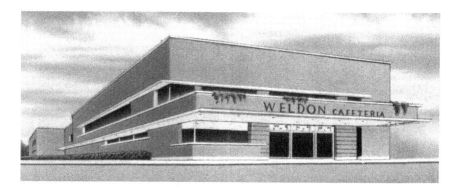

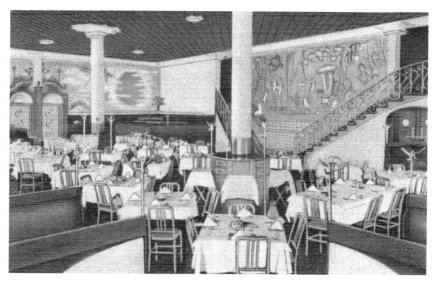

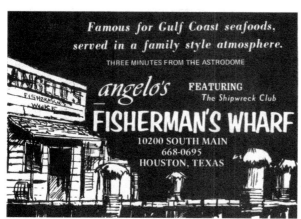

Top: Weldon Cafeteria. *Courtesy of the Trustees of the Boston Public Library.*

Middle: Ship Ahoy… Houston's Leading Restaurant. The back reads, "Ship Ahoy. The most famous restaurant in the south. Specializing in superb seafood and supreme steaks." *Authors' collection.*

Left: Angelo's Fisherman's Wharf. *Authors' collection.*

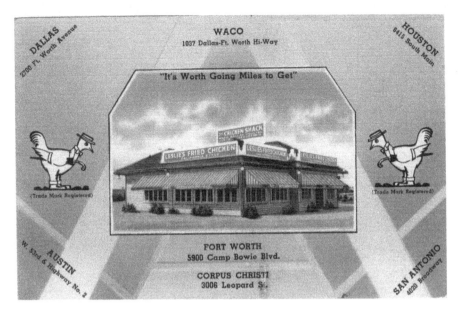

Leslie's Fried Chicken/The Chicken Shack. "It's Worth Going Miles to Get." *Authors' collection*.

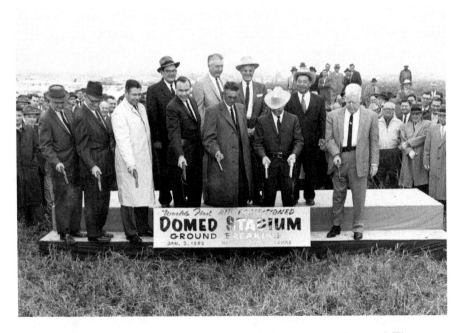

Dignitaries, in typical Texas style, using guns instead of spades to break ground. The baseball team was called the Colt 45s. *Houston Chronicle archives*.

A PERSONAL PERSPECTIVE

We moved to Houston from London in 1978. I was born in London into an Italian family, and Christiane was born in Kiel, Germany. We met while at university in London. While we did not grow up here, as the old saying goes, "We got here as soon as we could." We were married in the Rice Memorial Chapel and have made Houston home ever since. Houston is where our daughter, Jacqueline, was born and lives.

The things we missed most from Europe were crusty bread, good coffee (particularly espresso) and good beer, since none of these was readily available in the late '70s. We solved these problems by making our own bread and beer, and as for the coffee, we switched to tea until the coffee culture developed. We had to wait until the first Starbucks opened in Highland Village in December 1996 in order to get a good cup of coffee.

I grew up in a family of restaurateurs. It was an Italian family; therefore, it was quite large. My father was one of twelve children—my mother, one of five. Between my parents and all my aunts and uncles, they owned nine restaurants, all in the heart of London. There was a total of eleven children in the next generation, and while most of us helped out in the restaurants in various capacities while growing up, only one ended up in the restaurant business and for only a short time. Eventually, all the restaurants were sold, and none survives today.

We sat down with Ann Criswell, retired food editor for the *Houston Chronicle*, for a leisurely lunch and to talk about this project. Once the conversation turned to who could name more lost restaurants from

memory, I quickly gave up and reverted to a list that I had developed. There were very few that she was not aware of. Ann joined the *Chronicle* staff in April 1961 as the home furnishings editor. In 1962, she was named the society editor; then in 1966, Ann became the first editor of the first food section in a Houston newspaper. She remained the food editor until she retired in 2000. During her thirty-four-year tenure, not only did Ann witness firsthand Houston's changing food landscape, but she also influenced more Houstonians in their choice of cuisine and ingredients than any other person. "I became the food editor at the best time in Houston's development. More changes in food took place during the time I was food editor than at any time since Columbus," Ann noted. Both major Dallas newspapers, the *Times Herald* and the *Morning News*, already had food sections, so it was decided Houston needed the same. One week after the *Chronicle* started the food section, the *Houston Post* started one too. Ann remembers the first food sections. "They were twenty-six to thirty pages long. It was like producing a little newspaper by yourself, and I often felt it was like having a baby every week," she recalled. For many years, each *Chronicle* food section contained seventy-five recipes. This was, after all, the way many homemakers learned about new ingredients and cooking methods. Houston was still a "meat-and-potatoes" town, so her recipes reflected that. She watched Houston grow into what she described as "a top-notch restaurant town with world-class creative and innovative chefs." Houston evolved from a "beef-beer-and-barbecue town, to a fine dining mecca" she said in an article announcing her retirement. From the time when you could not order liquor by the drink in Houston, Ann has fond memories of going to many events and seeing society women in their couture gowns carrying brown paper bags. "There's something very amusing about that."

WHY RESTAURANTS FAIL

Opening a restaurant is not for the faint of heart. In addition to the hard work and long hours it takes to run a restaurant, there is also the question of how long it might last, although most entrepreneurs don't give that much thought when they're about to open up—they get too wrapped up in the euphoria of opening.

I have been an adjunct faculty member of the Department of Marketing and Entrepreneurship at the Bauer School of Business at the University of Houston for over thirty years and a keen observer of the restaurant trade. These are some of my observations as to why restaurants fail:

- The barriers to entry to open a restaurant are relatively low, so competition is high.
- The old adage location, location, location. If you don't pick the right one, look out.
- Insufficient parking. No foot traffic. Houston is not a walk-up city. If we can't find a spot to park within ten feet of the restaurant entrance, we will likely go elsewhere.
- Customers age and eventually die off and are not replaced with younger ones.
- Quality of food or service diminishes.
- Labor, ingredient costs and taxes become prohibitive.
- A developer buys up the property to turn it into something more lucrative.

- Many restaurants are sole proprietorships. The restaurant's fate is tied to its owner—if something happens to the owner, there is no plan B.
- An independent restaurant does not have the purchasing power of a large chain of restaurants.
- No succession planning. Many children of restaurateurs do not want to go into the business, as they see the amount of work involved in owning and running a restaurant.
- People always flock to the latest shiny object or, in this case, the latest chef/trend/fad/restaurant opening, leaving older or more established restaurants looking for new customers and facing increased competition for the same number of customers.
- Neighborhoods change. New areas of town become hot while other areas of town cool down.
- The area where the restaurant is located becomes gentrified, increasing the value of the property and making the tax burden unmanageable.
- Fads fade. Tastes change.
- An economic recession means people eat out less.
- Chefs get stale and do not reinvent themselves. Menus and dishes also get stale and need refreshing.
- As the old saying goes, "When the cat's away..." If the restaurant is a sole proprietorship, the owner cannot possibly be present 24/7, so the temptation for some employees to steal in the owner's absence is great. By the time the owner becomes aware, it is often too late.
- The inability to find qualified staff and high staff turnover.
- Failure to modernize the décor and stay up with the times.
- Poor reviews on social media or Yelp, Zagat, Trip Advisor and so forth.

We asked Chris Tripoli, founder of Houston-based A La Carte Foodservice Consulting group, who specializes in consulting to the restaurant industry, for his expert views on why restaurants fail. Here's what he said:

> First, let's dispense with the myths.
> **Myth no. 1** is that 90 percent of all restaurant start-ups fail. You may have heard that stated many times. I do not know where or how it got started, but it isn't true. A few years ago, a national survey was done and

found that 26 percent of startups actually closed within their first year of operation, another 19 percent failed during their second year and 14 percent failed during their third year. The takeaway is that starting up a restaurant for the first time is probably the riskiest of all retail but not impossible and can certainly be accomplished. Opening a restaurant for the first time isn't about being scared but all about being prepared

Myth no. 2 *is that all restaurants have huge margins and make large profits. In reality, the average independently owned restaurant creates a pretax profit of 7 percent to 8 percent. As volume increases, it is possible for the pretax profit percentage to grow too, but sadly, opening and operating a restaurant provides a far less profit-making opportunity than many first-time startups were expecting.*

Myth no. 3 *Quality, service and cleanliness equals success and profitability. Although restaurants are nothing without the basics, today's restaurant environment is much more competitive and our customers are much more educated, making QS&C not the ultimate objective but simply the cost of admission. Restaurant start-ups must be able to maintain quality standards daily, provide friendly service consistently and keep the facility clean always....But additionally, they must offer a well-developed concept with obvious point of difference and a great perception of value in order to be successful.*

Common startup mistakes: *Trying to do too much within the concept. Too many start-ups try to be everything to everybody, when what the guest really wants are places that specialize in particular segments of cuisines and/or experiences.*

Not having enough working capital. Opening budgets should include contingencies for items that may cost more than originally budgeted as well as a working capital amount equal to ninety days of fixed costs.

Opening before staff has been trained completely. This happens incredibly too often. It seems like owners of first-time start-ups can smell the finish line and hurriedly reach for it instead of properly preparing their staff. I believe a well-prepared opening means no one knows it's a first-time restaurant but the owner. The guests should see a well-designed, well-organized and well-executed operation right from the first day!

Lack of industry experience. It isn't true that in order to be a successful restaurant owner you must be very experienced in restaurant work positions and management, but it certainly helps. I have always recommended that first-time start-ups without industry experience intern or assist in a restaurant that's similar to what they plan to open. A little exposure to the

day-to-day work environment goes a long way and can prove invaluable experience.

Having unrealistic expectations. Some restaurants fail because they were poorly financed from the start. Some start-up operators have unrealistic expectations regarding the number of guests they will serve daily and the amount of revenue they will create with their concept. After opening, reality sets in and they find they have structured a deal that is too expensive for the type of restaurant concept they have created.

Why do start-ups do it? *They are passionate! It's for the satisfaction of being able to set a goal and accomplish what can be a life-long objective.*

Long-term wealth potential. Because it is possible to successfully operate a restaurant and pass it on to future generations.

Expansion possibilities. Creating a company out of a concept that can be replicated and possibly franchised.

To eventually sell or be merged into a larger hospitality company.

The downsides: *Tremendous personal liability. On leases, loans, licenses and even prime vendors. Finding the right partners. Many failures happen because of partner disputes.*

Finding financing. Start-ups typically cost about twice what their creators originally thought to open. Most first-time restaurants raise their funding through what we call the "combo platter" because it is the combination of landlord's tenant improvement dollars, personal equity, angel investors and a small loan or equipment lease.

Lifestyle. The hours are demanding, and the commitment is high and constant. Many start-ups underestimate the time commitment and changes it can create in their personal life.

WHY WRITE THIS BOOK?

Most people reach a point in their lives when instead of looking forward, they begin to look backward. Older people love to reminisce and think about what they perceive as the good old days. And why not, since life is made up of memories and bringing those memories back to life makes people happy? For some, this will be a personal trip down memory lane. For others, this will be a glimpse of how things used to be from a historical perspective.

If you search the Internet for old, closed or defunct restaurants in Houston, you will find lots of nostalgic posts on this subject. Most people love to remember meals they had at various restaurants. There are Google groups dedicated to keeping alive the memories of restaurants of the not-so-distant past. There is also the Houston Architecture Information Forum (HAIF), which has a very active forum, "Defunct Houston Restaurants." EGullet has a forum titled "Houston Remembers." Yelp has a section called "Closed Restaurants you wish you could Yelp." Chowhound has a section called "Vanished Restaurants You Miss Most." Pinterest has a board called "Explore Houston Nostalgia," and Facebook has "Remember in Houston When."

If you read through the messages on some of these sites, you come across some that just stop you in your tracks as we realize just how much we take for granted today:

- "I saw a live Maine lobster in a tank for the first time (the '50s) at Bud Bigelow's."
- Speaking of Kaphan's, one commentator said, "According to my dad, [it was] one of the first 'nice' restaurants to integrate." Also at Kaphan's, "I remember them teaching me the strange 'etiquette' of BYOB and ordering set-ups. That was in the days that you couldn't order liquor by the drink."
- Angelo's: "Where I had my very first oyster because I was told it would grow hair on my chest."
- Uncle Tai's: "It was truly great Chinese before there was such a thing in Texas."
- Valian's pizza: "I watched the other people in our party because I didn't even know how to eat it. I picked up my very first slice of pizza and before I could get it to my mouth, the sauce, cheese, and meat slid off onto the front of my white linen suit."
- Trader Vic's: "My mother saw a kiwi for the first time there."

These comments help us to better understand and appreciate that the cornucopia of food we have at our disposal today from every corner of the globe and at all times of the year was certainly not available to previous generations. Finally, we wrote this book to preserve a tiny sliver of the cultural heritage of Houston.

Writing this book has led us to an observation that the lifespan of an independent restaurant is around fifty years. Let's say a young chef, eager to get started in the restaurant business, opens a place sometime in his twenties and works until he can work no more, let's say somewhere between seventy and seventy-five. His children are not interested in pursuing the same career, so he sells it to someone who immediately changes the name and concept. Of course, there are exceptions to this, but these appear to be quite rare.

The hardest part about writing this book was deciding which restaurants to write about and which to leave out. The popularity of the place certainly figured in the decision, as was its importance from an historical food impact perspective. In addition, we wanted to showcase diversity—otherwise we might have included only steakhouses. And lastly, we took into consideration the accessibility of source material such as photos, old menus and even surviving relatives.

While researching information for this book by scouring blogs and websites that talk about the Houston of yesteryear, by reading old issues of the newspapers and magazines, we came across a lot of Houston restaurants that no longer exist. We started to develop a list of all we found. We stopped at eight hundred but are convinced that this is but a fraction of those that have come and gone.

OLDEST HOUSTON RESTAURANTS THAT ARE STILL AROUND

Since we started writing this book, another old place closed (July 2017): Guy's Meat Market. It opened seventy-nine years ago, in 1938, and was a tiny place with no seating—you had to get your food to go and eat in your car or simply take it with you. Guy's was famous for its BBQ and hamburgers. The kitchen only made 250 of them each and every day, and there was almost always a line out the door. When they ran out, they ran out. The patty had been smoked in the same smoker used to smoke all the meats, and the taste was unforgettable. Now, you won't be able to taste it anymore. It was the only place in town that made a smoked hamburger. There is no place left that makes such a thing.

Up to now, we have talked extensively about Houston restaurants that no longer exist. At this point, we decided to provide a list of some of the oldest restaurants, cafés and bakeries in Houston and some surrounding areas in the hopes that you will visit them soon before some of these places end up in a future book on lost restaurants. The places listed here are at least fifty years old, more or less, and three are over one hundred years old. The restaurants are listed in the order of the opening date. One interesting observation about this list is that nine of the forty-six places listed here specialize in hamburgers, which would suggest that burger joints appear to be more resilient than other types of restaurants.

Original Mexican Café (1908, Galveston)
Gaido's (1911, Galveston)
Christie's Seafood and Steaks (1917)
James Coney Island (1923)
Yale St. Grill (1923)

West Alabama Ice House (1927)
Moeller's Bakery (1930)
Prince's Hamburgers (1932)
Pizzitola's BBQ (1934)
Shipley's Donuts (1936)
Avalon Diner (1938)
Brenner's Steakhouse (1938)
Lankford's Grocery & Market (1938)
Donnelly's (1939, Baytown)
Tel-Wink Grill (1940)
Cleburne's (1941)
Molina's (1941)
Massa's Oyster House (1944)
Barbecue Inn (1946)
Cream Burger (1946)
Harry's Restaurant (1948)
The Last Concert Café (1949)
Three Brothers Bakery (1949)
Goodson's Café (1950, Tomball)
City Café (1952)
Leon's Lounge (1953)
Spanish Village (1953)
Doyle's Restaurant (1954)
Frank's Grill (1954)
Someburger (1955)
The Original Kolache Shoppe (1956)
La Carafe (1958)
This Is It (1959)
Stanton's City Bites (1961)
Champ Burger (1963)
Poppa Burger (1963)
Demeris BBQ (1964)
El Patio (1964)
Tony's (1965)
Brennan's (1967)
Dot Coffee Shop (1967)
The Flying Saucer Pie Company (1967)
Mytiburger (1967)
Burger Park (1968)
China Garden (1969)
Frenchy's (1969)

The Lost Restaurants of Houston

The remainder of this book is devoted to twenty-four restaurants that all played an important role in the development of the city. Each was picked for its contribution to the restaurant industry in Houston, its popularity, the degree of nostalgia and regret its disappearance inspires and, lastly, the availability of source material.

ALFRED'S DELICATESSEN

(1948–97)
2408 RICE BOULEVARD
9123 STELLA LINK ROAD
520 TOWN & COUNTRY VILLAGE

Alfred Julius Kahn was born in 1918, in Tholey, Saar Basin, Germany. He came to Houston in 1936 with his cousin Bill Meyer after escaping from the Nazis. Kahn joined the army and fought with the Allies in the Pacific during World War II. Upon his return to Houston, he started working at Leon's Delicatessen & Restaurant, a kosher deli at 2408 Rice Boulevard in Rice Village. Leon's was founded in 1925 by Robert Leon and his brother, Joe. The name Leon's was changed to Schwartzberg's at some point in the 1940s, when another Leon brother married a Schwartzberg. Alfred Kahn later bought part of Schwartzberg's, becoming the sole owner in 1946. He ran the business for two years until his lease expired. In 1948, Kahn opened Alfred's Delicatessen and Sandwich Shop in the same location.

Alfred's was famous for a number of items, including hearty soups, all made from scratch, like chicken noodle, lentil, barley and mushroom, potato and borscht. He also made an excellent brisket, stuffed cabbage, corned beef, chicken and dumplings and potato pancakes. Desserts included apple strudel and a wonderful cheesecake. Over-stuffed sandwiches included all kinds of deli meats like pastrami, corned beef, chopped chicken liver and

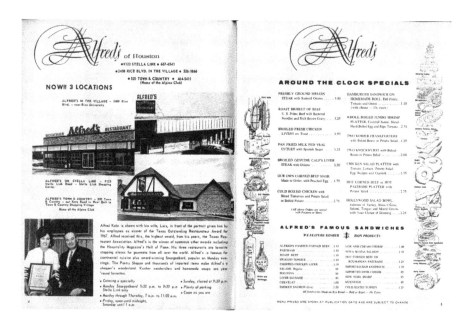

Above: *Dining Out in Houston*, vol. 7, 1972. *Hospitality Industry Archives, Hilton College, University of Houston.*

Left: Alfred's Restaurant, Delicatessen, Pastry Shoppe. *Authors' collection.*

pickled tongue. Most sandwiches were served on rye or pumpernickel bread. He introduced Houstonians to the Reuben sandwich and to one he called the "Texan," a sandwich with a mound of roast beef covered in coleslaw and Russian dressing. Breakfast included lox and bagels and eggs scrambled with lox and onions.

In 1958, Kahn opened a store on 9123 Stella Link Road near Loop 610. It was a gourmet food store in front and a full-service restaurant in the back. The interior was all wood paneled. At the front counter, you could buy deli meats, smoked fish and cheese and order the oversized, custom-made sandwiches. This is where on Monday evenings he offered his smorgasbord. This location also had a pastry shop. In 1968, he opened a restaurant in Town & Country Village. Starting in the early '80s, his daughter, Susan Adams, took over the operation, but Alfred still visited all three locations every day. The last member of the family to own a restaurant was Alfred's stepdaughter, Karen Lara, who opened K. Deli in 1986 on 6579 West Bellfort Road.

The Rice Village store closed in 1982, but in 1984, Alfred's son, Michael Kahn, opened Kahn's Deli across the street at 2429 Rice Boulevard, having heeded his father's advice to gain experience by working for someone else. In his case, it had been Antone's. His place was a small, narrow shop front with a few stools and a counter. Like Alfred's, Kahn's also offered soups and bagels, but the specialty here was the sandwiches. One sandwich that earned him lots of kudos was the Olajuwon Special, named after the Houston Rockets' famous player. It consisted of a French roll slathered with homemade Russian dressing, melted swiss and cheddar cheese, sauerkraut, spicy mustard, a mound of corned beef and sliced knockwurst.

It closed in 2015 after Mike sold it to a lady with no restaurant experience who was unable to make a success of it. Shortly thereafter, Helen's Greek Food and Wine took over the space that Kahn's Deli had occupied in the Village, expanding into the space next door as well.

Ann Criswell, the retired editor of the *Houston Chronicle*, related a story to us about the first time she ate at Alfred's. She ordered a pâté and cheese sandwich, "and it scandalized them. They didn't know what to do since it is prohibited in Jewish dietary law to eat meat and dairy at the same time."

Alfred Kahn had an annual charity dinner that benefitted the B'nai B'rith Youth Organization and Seven Acres Geriatric Center. He died in 1995 at the age of seventy-seven, after putting in a full day's work.

ANTONE'S IMPORT CO.

(1962–2003)
807 Taft Street

*J*alal Antone was born in 1912 to Lebanese parents in Jennings, Louisiana. He moved to Port Arthur, then to Houston in 1935 to become president of a chain of distributors called European Imports. He created the Houston Po' Boy in 1962, when he opened Antone's Import Company on Taft. It was a large place resembling a warehouse, full of shelves stocked with exotic food products from all over the world. One might call it a mini version of Phoenicia Market. It soon turned into a gathering place for the foreign community in Houston, all seeking comfort foods from their home countries. Antone's Import Co. was the greatest food emporium Houston had to offer for many, many years. People sat on kegs and crates with barrels for tables and sampled some exotic foods like snails, squid in their own ink, conch and salted eel. There were myriad kinds of pasta and tomato sauce, one hundred different cheeses, fifty different sausages and lots of spices. But it was a po'boy that made Antone's famous.

What distinguishes the Houston Po'Boy from any other variety, and there are lots of them, are three things: the bread, the chow-chow relish and the fact they are served cold. If they reached room temperature—or heaven forbid, if someone actually nuked them—they simply did not taste the same. The bread came from the Royal Bakery on Fairview at Dunlavy, which is still going strong. The loaves were ten-inch-long French-style loaves with a

very thin crust, which could be easily pressed down to almost nothing. They were not crispy like the French loaves used for Vietnamese banh mi, neither were they as soft as Parker House rolls. The chow-chow was a traditional southern relish. It was orange-red in color with just a hint of heat and made from cabbage, vinegar, sugar, onions, green peppers and hot peppers, paprika, turmeric and other spices. The process of making the sandwiches involved mixing the chow-chow with the mayonnaise before slathering it on the sandwich. This tiny detail meant that the chow-chow was not as runny as if it had been spread on the sandwich by itself. When Antone's opened in 1962, po'boys were fifty cents apiece.

While there was a variety of different sandwiches available, the two best sellers were the classic (green sticker) and the super (red sticker), which had more meat and cheese than the classic. Other offerings were a tuna (blue label) and a piggy (black label). The classic consisted of ham, salami, provolone, chow-chow, mayonnaise and slices of dill pickle. They became a staple for a fast lunch, and the original location on Taft was only a few minutes' drive from downtown. You could watch the sandwiches being made and placed in large plastic bins ready for sale. Each was wrapped in butcher block paper, which was waxed inside. On the outside was a different colored sticker designating the contents of the sandwich. Biting through the bread to the meat and cheese and experiencing the sweet and sour chow-chow and the salty meat and cheese was one of the most wonderful taste experiences you could possibly imagine. For many Houstonians, the Antone's Po-Boy was the epitome of a sandwich, and when it was introduced, it was quite exotic for its time.

Jalal was also one of the original founders of St. George Orthodox Christian Church in Houston. He died in 1974, leaving behind a chain of three stores. In his will, Jalal left 98 percent of the company stock to his wife, Josephine, and 2 percent to his daughters, Mary Jo Antone (Hatfield) and Jamie Lee Antone. In 1978, Josephine signed a licensing agreement that allowed her daughters to start their own company and use the Antone's name, trademark and recipes. Josephine continued to operate the three original stores and a warehouse under the name Antone's Import Company, with a two-and-a-half-mile radius of exclusivity surrounding each of the original restaurants. In addition to the store on Taft, Josephine also owned stores at 3823 Bellaire and 8057 Kirby. The rest of the city was open to the daughters to expand under the company name of J.J. Gregory Gourmet and operate under the name Antone's Po'Boy and Deli and, later, Antone's Famous Po' Boys. Unfortunately, the agreement prohibited the

mother from expanding beyond the three original stores. The daughters' expansion was rapid. All through the late 1980s, the two factions of the family feuded intensely over the agreement. Josephine sued the daughters, then the daughters countersued their mother and mother sued daughters once more. The arguments were still going on as late as 1993. In 1996, J.J. Gregory Gourmet Services declared Chapter 11 bankruptcy. In the fall of 1996, a real estate investor, Neil Morgan, received bankruptcy court approval to buy J.J. Gregory Gourmet Services, which still owned five Antone Import stores under the newly formed Hamlet Restaurant Group. Previously, Morgan had been an investor in Café Express and Café Annie and the developer of the Park 10 complex. In September 1997, Morgan hired Ben Litalien to run the operation. They expanded the menu and the stores, and distribution started through gas stations. They partnered with Exxon Mobil to sell their po'boys in Tigermarkets, which were just beginning to be developed. They started to look into franchising the operation and expanded to Nashville. Since 1962, mayo and chow-chow had been the only spreads ever to come into contact with an Antone's Po'boy. That changed in 2002, when the company added spicy chipotle, creamy horseradish and honey Dijon to the offerings. By 2002, there were fifteen stores in Houston and Austin. Josephine "Mama" Antone died in March 2003, and on December 31, 2003, the store on Taft served its last po'boy. All the fixtures were sold off as well. When Antone's closed, it was taken over by Gravitas, which closed in 2011. Today it is the Pass & Provisions restaurant. During the construction of Pass & Provisions, workers came across an old sign for the original Antone's store. It was decided that it should be kept in homage to the roots of the building and now hangs in the Pass.

In 2008, Legacy Restaurants was formed with Chris Harter, the president and CEO. The company owned the Ninfa's on Navigation and the four Antone's stores that remained. Harter's goal was to "modernize it while bringing back its original vision," as he said in an interview with the *Houston Chronicle* in March 2008. The prototype store, which opened in March 2008, was called Antone's Market and River Oaks Café, at 2311 West Alabama. In 2008, the three original Antone's Import Company stores were owned by Vana Inc.

Today, there are only four stores remaining: Antone's Import Company Original at 8057 Kirby and 3823 Bellaire and Antone's L.P. at 4530 San Felipe and 2724 West T.C. Jester. Antone's L.P. also has two kiosks, one in Greenway Plaza, the other in the downtown tunnel system. The po'boys are also for sale in area Kroger and Randall's stores.

Chow-Chow

I small cabbage, shredded
½ cup shredded green bell pepper
I small onion, shredded
⅓ cup vinegar
¼ cup sugar
I teaspoon celery seeds
½ teaspoon dry mustard
½ teaspoon turmeric
½ teaspoon paprika
¾ teaspoon cornstarch, mixed in 2 tablespoons cool water
I pinch cayenne pepper
I pinch salt

Place all ingredients in a pot, cover and simmer on very low for 2–3 hours, until softened. Do not add any additional liquid. Once cool, place in jars and refrigerate.

BILL WILLIAMS CHICKEN HOUSE

BILL WILLIAMS CHICKEN BAR
806 CLAY STREET (1935–36)

BILL WILLIAMS CHICKEN HOUSE
6515 SOUTH MAIN STREET (1936–73)

BILL WILLIAMS MACGREGOR HOUSE
5100 OLD SPANISH TRAIL

BILL WILLIAMS MOTEL AND RESTAURANT
HIGHWAY 59 AND 90-A

Bill Williams arrived in Houston from Alabama in 1929 at the age of nineteen. He was on his way to Hollywood to join a cousin in the film industry but never made it past Houston. He spontaneously took a job as a short-order cook at one of the One's A Meal restaurants downtown. After five years, he quit because he was not promoted to night manager. Instead, he decided to move to Chicago. However, L.B. Hamilton, a Houston oilman and regular customer of the restaurant, heard about Williams's plans and persuaded him to stay in Houston. Williams told Hamilton he needed $500 to open his own restaurant. Watching Hamilton dig into his pocket and peel off five $100 bills, Bill could hardly believe his eyes and good fortune. The small Chicken Bar at 806 Clay opened in 1935.

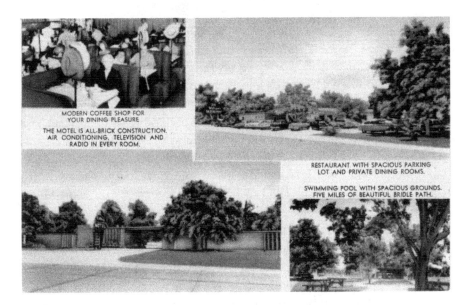

MODERN COFFEE SHOP FOR
YOUR DINING PLEASURE

THE MOTEL IS ALL-BRICK CONSTRUCTION.
AIR CONDITIONING, TELEVISION AND
RADIO IN EVERY ROOM.

RESTAURANT WITH SPACIOUS PARKING
LOT AND PRIVATE DINING ROOMS.

SWIMMING POOL WITH SPACIOUS GROUNDS.
FIVE MILES OF BEAUTIFUL BRIDLE PATH.

Bill Williams Motel and Restaurant. *Authors' collection.*

In 1936, Williams opened Bill Williams Chicken House on 6515 Main. The location was opposite the original Rice stadium and had both a dining room and drive-in. Rice University used this stadium as its football venue until 1950, when the new seventy-thousand-seat location was built on campus. This location was one of a few places along Main Street near the campus where Rice students ate on weekends, when there was no food available in the dining hall. Upstairs, there was a banquet room that sat two hundred people, which was used by many a graduating class. During the mid-1940s, business declined due to increased competition from other fried chicken restaurants and the fact that it was more economical to cook at home, so Williams added an oyster bar and expanded the menu to include seafood. In 1946, oysters were seventy cents a dozen.

Bill Williams opened another restaurant on Old Spanish Trail called Bill Williams MacGregor House and yet another one in Richmond, Texas, with many different dining areas. One dining area offered white-tablecloth service while the other area offered drive-up carhop service. Sometime around the early 1950s, he added to the grounds a motel, amusement park and a train and horse rides going down to the Brazos River. After the location closed, it turned into a country and western bar called the Wounded Armadillo.

Bill Williams became known as the "Chicken King," as well as the "Chicken Czar." From 1935, when he only had a shack, until 1941, his slogan was "Chicken in the Rough." In 1942, the slogan changed to "Savage Style Fried Chicken." This is what made Bill Williams famous. The 1946 menu shown here puts the price of a regular order of fried chicken at sixty cents. However, it also features other offerings, such as chicken livers, gizzards and giblets, which were all common items at the time. There was a wine list, but apparently, you had to ask for it. The cover of the menu depicts the evolution of Williams's restaurants, from his original shack in 1935 to his much larger restaurant on Main. In 1938, the front of the restaurant on Main had six chickens on the top and a plate of fried chicken over the door. In 1942, the chickens had gone, replaced by a picture of a Native American cooking over a campfire. Later, this turned into two three-dimensional figures of Native Americans, one kneeling, the other sitting cross-legged, cooking in a pan over a campfire. At night, the campfire lights flickered so that it appeared as if the fire was burning and the figures were outlined in neon lights. The lights also showed the arms of one of the Native Americans as if lifting the chicken out of the pan.

In addition to being a successful restaurant owner, Bill Williams was a generous philanthropist and a big supporter of the Houston Livestock Show and Rodeo, which was founded in 1932. An article titled "Preparing the Fatted Calf" by William C. Martin in the February 1974 edition of *Texas Monthly* relates a little of Williams's charitable history:

> *Houston restauranteur Bill Williams has bought more champions through the years than any other patron of the show. In 1937, he paid seventy dollars for the Grand Champion Chicken. Twenty men subsequently offered him five dollars apiece for a chicken dinner. Williams accepted their offer, but insisted the money go to charity. This was the beginning of the annual Bill Williams Charity Capon Dinner, which contributes over $100,000 a year to charitable causes. In 1964, Williams paid $20,500 for the top steer, which he mounted and displayed in his Main Street restaurant until it was torn down last year.*

Some claim that, over his lifetime, Williams donated more than $3 million to charity.

People remember the stuffed steer in a glass case inside the restaurant. They also remember the mechanical fortuneteller, an old woman in a glass

Left: *Houstonian* advertisement for Bill Williams, 1957. *Special Collections, University of Houston Libraries, University of Houston Digital Library, http://digital.lib.uh.edu/collection/yearb/item/2652/ show/2647.*

Right: Advertisement for Bill Williams, 1952. *Rice University, Campanile Yearbook, Houston, Texas.*

box, that was by the door. When you inserted a coin, she would run her hands over some cards in front of her then stop on one that was to be your fortune. A card with your fortune printed on it would drop into a slot underneath, where you could collect it. Apparently, the old fortuneteller looked so real, it scared many a young child, giving them nightmares.

The phrase *Savage Style* was described in this ad for Bill Williams Chicken-in-the-Rough. Williams told his patrons to "eat it with your fingers…savage style." This was something totally new in the mid-1940s. At that time, eating chicken with your hands may well have been the custom at home, but not in a restaurant.

The fate of the two Native American figures that used to sit atop the restaurant on Main Street was described to me by Dennis Griffin, who owns the one that held the skillet over the fire:

> *Mr. James Wheeler was employed on the restaurant's demolition crew and obtained the rights to both Indian figures and moved them to his Fort Bend County family property. The property was divided and Jim*

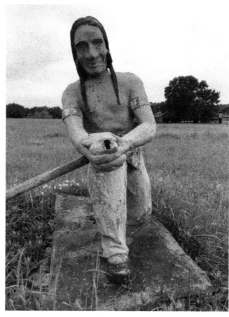

Left: Bill Williams Chicken House postcard, 1946. *Annette Gano scrapbook, Rice University scrapbook collection, box 6, UA 230, Rice University Archives, Woodson Research Center, Fondren Library.*

Right: *Courtesy of Dennis Griffin.*

sold his portion, bought a retirement home near Lake Somerville in Burleson County, and took the skillet-holding Indian with him. The other Indian remained in Fort Bend County where it was. I wonder where it is now? Mr. Wheeler's retirement home was in Birch Creek Forest subdivision on the north side of Lake Somerville. After many years, Wheeler sold that home and the buyers insisted on him leaving the Indian behind—which he did. After a few months, the new buyers opted to dispose of the Indian to make room for other improvements and offered it for sale to me. I thought the offer might have been a whim, so I only thought about it for two seconds before consummating the deal. A few days later, on a weekend afternoon, the Mrs. and I loaded it onto a trailer and transported the Indian the eighteen miles into Somerville where it sits today. That unannounced trip was a wild one, with passersby "rubbernecking" and taking pictures. The seller's subdivision neighbors were sorry to see their landmark leave but were relieved that it did not go far.

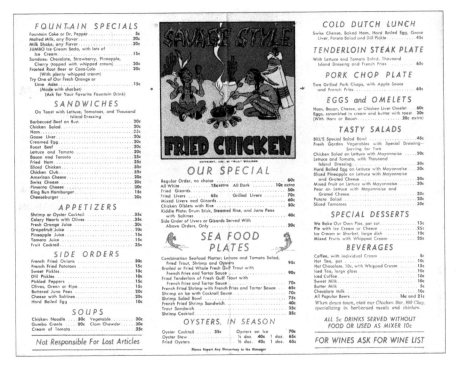

Bill Williams Chicken House menu, 1946. *Annette Gano scrapbook, Rice University scrapbook collection, box 6, UA 230, Rice University Archives, Woodson Research Center, Fondren Library.*

> *The Indian occasionally "stands in" for the mythical Yegua Indian, which is Somerville's school mascot. In that way, he can be found in a few school yearbooks or viewed on a field trip from the school. He's our family's official Somerville greeter.*

Bill Williams died in 1984 at the age of seventy-two. One side note concerns Benny Heinemann, who had been an oyster shucker at Bill Williams until it closed in 1973. Out of a job, he bought an old shrimp boat, cut a hole in the side, added a cooler and a bar and started serving oysters on the half shell, boiled shrimp and ice-cold beer. He called it Captain Benny's Oyster Boat, and it was located at Holcombe and South Main. He later moved to near Main and Greenbriar and moved again to Main Street near Old Spanish Trail.

Bill Williams Fried Chicken

Vegetable oil
½ cup buttermilk
½ cup milk
1 cup flour
½ teaspoon paprika
½ teaspoon spicy seasoning
Salt and pepper to taste
2- to 3-pound fryer, cut into pieces

Heat 1 inch oil in large, heavy skillet. Mix buttermilk and milk in one dish. Mix flour and spices in another dish. Dip chicken pieces in flour mixture, dip into milk mixture and then dip chicken a second time in flour mixture. Fry until lightly browned on one side, about 5–7 minutes. Turn chicken pieces over and cover with a tightly fitted lid. Cook another 10 minutes. Turn chicken pieces again, cover and cook another 10 minutes.

BUD BIGELOW'S

BUD BIGELOW'S CHARCOAL HOUSE
7939 WESTHEIMER ROAD (1955–82)

When it first opened in the 1950s, Ervin S. Bigelow's restaurant, known as Bud Bigelow's, was an independent restaurant located in what was considered to be at the time the very edge of town. It was even described by some as being "way out west," even though it was situated between Hillcroft and Fondren, which today would almost certainly be considered in town. It later became a part of what was at the time called Steak House Associates, which was a chain of restaurants, including the Stables, Bordman's and the Courtyard. This association was formed to enable the owners to benefit from standardization of equipment and supplies and economies of scale in purchasing. In 1965, Ervin registered the name Bud's Dinner Club at the same Westheimer location, but it does not appear that he ever officially used this name.

In an interview he did for Chef's Chat with the *Houston Press* on January 7, 2015, Arnaldo Richards, owner of Pico's Restaurant, said that when he returned to Houston in 1978 from Mexico, he went to work at Bud Bigelow's, which "was *the* steakhouse in Houston." He went on to say, "I thought I would just do that for six months and then go back to the kitchen, but I was making so much money, it was difficult—to go from making $7,500 a month back to making $10 or $12 per hour. I was there for almost two and a half years. That really put me through school. I was making enough money to be able to afford my school and do it fast."

Bud Bigelow's was famous for selling "excellent steaks at realistic prices." It was also known for serving complimentary seconds of Bud's Famous Crisp Romaine Salad and for being the first to bring a mini loaf of hot bread to the table before the meal. Bud's also served toast points with a cheese spread to keep the hunger away. A menu from the period describes the atmosphere as follows: "A relaxing atmosphere is created by having several warm rooms reminiscent of a large house, where casual dress is permitted and service is relaxed and personal." Red and white checkered tablecloths, wood paneling and a fake fire always roaring in the fireplace added to the comfy and homey feeling. You could smell the charcoal from the parking lot as soon as you opened the car door. This was a great way to make people salivate on their way to the entrance.

What we know today as surf and turf was listed on the menu at Bud Bigelow's as "Reef & Beef—For those who can't make up their minds." The steaks were "charcoaled" and were available regular or extra thick. Prime rib was also a specialty, with a "limited amount available each evening to assure its succulence." Shrimp, scallops, stuffed crab, trout, lobster tail and king crab legs, fudge brownie pie with vanilla ice cream and the famous brandy freeze suggest that this was not an everyday meal but one meant for special occasions. In later years, live Maine lobsters were kept in tanks, something Houstonians at the time had not seen before. Detailed descriptions of wine varietals were listed on the menu to help educate Houstonians about ordering wine.

By the time Bud Bigelow's was on the verge of closing, it is obvious that it had to up its game and offer more than just basic steaks. The restaurant seemed to have morphed into more of an upscale locale with higher prices and offerings, such as oyster cocktail, artichoke hearts stuffed with fresh crab, *entrecôte de Paris* topped with a buttery escargot sauce, herb-seasoned lamb chops, crab with scallions and mushrooms and scallops and shrimp in Chablis.

CONFEDERATE HOUSE

SAN FELIPE (1948–72)
4007 WESTHEIMER ROAD (1972–93)
2929 WESLAYAN STREET (1993–2001)
THE STATE GRILL (2001–6)

Gordon Edge was born in 1914 in Edge, Texas, ten miles northeast of Bryan. Edge was named for Dr. John Edge, who founded the town in 1840. In 1910, just four years before Gordon was born, the population of Edge was fifty. By 2000, the population had barely doubled to one hundred. Gordon went to A&M on a basketball scholarship. He left A&M and graduated from Sam Houston College, then went into the U.S. Navy. After World War II, Edge moved to Houston, and in 1946, he opened Kay's on Bissonnet Street, which closed its doors for the last time in September 2016. Over the years, Kay's was known as Kay's Barbecue, Kay's Club Grill and Kay's Lounge, and it became a very popular bar. Edge started the Confederate House in 1948 as a private club to get around the local liquor laws when you could not get a mixed drink in a restaurant in Texas. This way, club members could get a mixed drink without having to resort to brown-bagging (how uncivilized!) their own liquor. Many people wanted to become members of the club, but Edge admitted only a select few. Above all, he wanted to ensure that the members of his club had a southern sensibility. What he was striving for in the Confederate House was to provide a good dose of southern hospitality and gentility. After Gordon's first wife,

Betty Faye, died in 1966, he met Betty Luedemann, and in 1969, they were married. Betty told me how Gordon started the restaurant with nine friends, each giving him $1,000. The restaurant was so successful that each investor was paid back his initial investment within three months. Edge's philosophy was formed by Helen Corbett, who was responsible for creating his menu. She told him to "keep it simple and buy quality." He took this to heart in his restaurant. Corbett started her career at the downtown Joske's Department Store, then moved to Austin to work at a hotel before returning to Neiman-Marcus, where she ran the restaurants.

The best way to describe the Confederate House is to let Betty Luedemann Edge, Gordon's wife, tell us how it was. She did this in her 1996 book, the *Confederate House Cookbook*:

> *This is as old guard Houston as you will find. With it's* [sic] *Southern décor, discrete* [sic] *staff and the best bartender in the city (according to many), the Confederate House is the place to spot Houston's blue bloods dining in multi-generational groups under portraits of rebel generals.*

One writer described the décor as if you were "on the set of *Gone with the Wind*." Another described the building on Weslayan Street as a "'structure that bears an unsettling resemblance to a classy mortuary'—courtly black waiters still dispense Gulf Coast country-club food to a well-heeled audience of vintage Houstonians." Yet another said that eating here was like "dining at a Southern plantation," and another described the place as a "bastion of paleolithic country-clubbiness." Indeed, all the waiters, dressed in white jackets and bow ties, were African American and all the customers old, white males. There was a Confederate flag in the bar and paintings of Robert E. Lee, Stonewall Jackson, Jefferson Davis, U.S. Grant and other generals scattered throughout the restaurant. There was also a tunic from a Confederate artillery major decorating one of the walls and pictures of ladies resting under Spanish moss–draped oak trees.

There was a general sense that the Confederate House exuded civility, southern courtesy and comfort in the food as well as the plush, comfortable chairs and large, widely spaced tables. Even when the restaurant was completely full, it was never noisy. The clientele was very loyal, and many had dined there for thirty or forty years. Regulars were not in need of a menu, ordering the same dish, prepared in the same way, time after time. Over the years, the Confederate House served a wide array of famous figures, from politicians, celebrities and sports figures to prominent

businesspeople and lawyers. Lyndon B. Johnson, John Connally, Mark White, George H.W. and Barbara Bush, George W. and Laura Bush and Tom Landry were among those who dined here.

While the menu was heavy on Gulf Coast seafood and included such items as crab-stuffed jalapeños, breaded and fried, shrimp cocktail with remoulade sauce, soft-shell crabs and red snapper, it was red meat that made a mark with filet mignon, prime rib, tenderloin and the famous CFS (Confederate Fried Steak) with mashed potatoes, fried corn and green beans among the offerings. Here, it consisted of a rib-eye steak wrapped in a blanket of crispy-fried batter. The chicken and dumplings was legendary, as was the Wilhelmina Salad, which consisted of iceberg lettuce, tomatoes, blue cheese and avocado. And for dessert, the Pecan Ball, a scoop of vanilla ice cream, encrusted in nuts and covered in warm bitter chocolate, elicited many fond memories from patrons. Even well into the '80s, men were reminded that a "coat and tie was required after 6:00 p.m."

In 1993, Gordon and Betty moved into the location on the corner of Weslayan Street and West Alabama Avenue, which had previously belonged to the Black Angus, opened by the Vargos family in 1953. Tony Vallone took over the Westheimer location from the Edges. Today, this location is where Smith & Wollensky operates. When the new restaurant opened on Weslayan Street, they installed the large crystal chandelier from the original location. Gordon had found the chandelier in New Orleans, where it was originally a gaslight fixture. When the restaurant closed its doors for the last time, the chandelier found its new home in the Museum of Southern History, which was located on the site of the Southern National Bank of Texas in Sugar Land from 2002 until 2007. It was built as a replica of Poplar Forest, which was the hideaway of Thomas Jefferson, seventy or so miles from Monticello, in Lynchburg, Virginia. In 2007, the museum was moved to the campus of Houston Baptist University, where the chandelier today illuminates the main lobby.

Gordon Edge died in July 1993, and in August 1999, Betty Edge, Gordon's widow, sold the restaurant to Frank Mandola and Joe "Bubba" Butera, cousins and business partners. They kept everything pretty much untouched for a couple of years until 2001, when the pair changed the name of the restaurant to the State Grille, deciding it was time to retire the old generals and a name that conjured up a past some wished to leave behind. While they kept the most popular items from the menu of the Confederate House, such as the Confederate Fried Steak, the Wilhelmina Salad and the Pecan Ball, they tried to update it with regional Texas

Confederate House charger (*left*) and plate from the authors' collection. *Photo by Paul Galvani.*

offerings. At the time, there was a concern that the regular customers of the old Confederate House would balk at the name change and no longer frequent the place. But Johnny was confident that 80 percent of the customers would return and, more importantly, that the name change permitted corporations previously concerned about frequenting the place to take clients there freely. Many of the old guard were upset, and Mandola recalls receiving letters from as far away as Alabama and Mississippi. A sale of the Confederate memorabilia helped the new owners defray the costs of changing the name. This sale of memorabilia is how we ended up with a plate and charger pictured here.

To many of the customers of the Confederate House, the restaurant was like a second home, and nowhere did they feel more comfortable than at the bar where John L., as he was known (his last name was Price), had taken care of them for over forty-four years. What they wanted was something and someone familiar. John soon learned to memorize the favorite drinks of all his regulars. His success was secured also because he was legendary for having a heavy hand when pouring a drink. John L. was quoted in an article on August 7, 1986: "We have a senior crowd at night, and they like what they've been drinking for years." That meant Bloody Marys, old fashioneds, whiskey sours and margaritas made from scratch. "We don't sell too many of these kamikazies," by which he meant newfangled concoctions.

Bartending at the Confederate House was John L.'s first and only job. His first day on the job in 1954 was his first time in any bar. For three

years, he apprenticed under George Crowder, who left in 1957 to open the Red Lion. John L. was made head bartender when George left. On most nights, the restaurant seated two hundred, with another fifty at the bar. John L. served them all, rich or poor, in exactly the same way—with a broad smile. He is reported to have served somewhere between three and thirteen million drinks over his career. So important was John L. to the success of the Confederate House that in 1990 he was inducted in *Bartender* magazine's Bartender Hall of Fame. The City of Houston declared August 29, 1997, as John L. Price Day through Mayor Bob Lanier, a regular customer of the restaurant.

In 2006, Giorgio Borlenghi of Interfin Cos. (Four Leaf Towers, Hotel Gran Duca and others) purchased the State Grille property, and in 2011, he sold it to PM Realty Group, which turned it into a forty-story high rise known as the 2929 Weslayan Apartments. It claims to be the tallest apartment tower in Houston.

Confederate House Chicken and Dumplings

1 whole 3- to 4-pound chicken, cut up
1 cup celery, chopped
1 cup carrots, chopped
1 large onion, chopped
*1 tablespoon Beau Monde®**
Salt
Pepper
1 ½ cups flour
3 teaspoons baking powder
2 egg yolks
¼ cup milk
½ cup chicken broth
1 teaspoon parsley

Fit chicken into large cooking pot with celery, carrots, onion and Beau Monde®, adding salt and pepper. Barely cover with water. Cover and cook till tender on simmer, approximately an hour. About fifteen minutes before chicken is done, mix flour, baking powder, egg yolks, milk and broth. Beat vigorously; if batter is thin, add flour. Using a

teaspoon, drop batter into boiling chicken and broth. When dumpling floats, the dish is ready. Garnish with parsley.

Adapted from *Confederate House Restaurant Cookbook*, by Mary Jo Bell and Betty B. Edge

*Beau Monde® is a trademarked seasoning made by Spice Island. If you are unable to locate it, you can make something very close by mixing together equal parts of the following: ground cloves, ground cinnamon, salt, ground bay leaf, ground allspice, ground black pepper, ground white pepper, ground nutmeg, ground mace and celery seed. It should be added to the pot when cooking the chicken.

FELIX MEXICAN

904 Westheimer Road
5208 Bissonnet Street
5829 Kirby Drive
719 Telephone Road
816 Main Street
105 West Bird Road, Pasadena
1718 Calder Avenue, Beaumont

Felix Mexican Restaurant, a Houston institution and Tex-Mex mecca for sixty years, closed its doors in 2008, forty-three years after the death of its original owner and founder, Felix Tijerina. The lamentations were widespread.

Tijerina was born in Nuevo Leon, Mexico, in 1905. His parents were migrants who worked in the sugarcane fields in Sugar Land. Tijerina, looking for a better life, decided to try his luck in Houston. At the age of thirteen, he found a job as a busboy at the Original Mexican Restaurant at 807 Fannin Street, Houston's first Mexican restaurant, owned by George Caldwell from San Antonio. It opened in 1907 and was a favorite of Mayor Oscar Holcombe.

Tamale vendors and chile stands, of which there were about a dozen, had been supplying Mexican food around Market Square dating back to 1885. At the turn of the nineteenth century, they were being shut down as

a result of a new awareness of food safety and hygienic food handling. The first health inspections began, and rules were developed for the handling of food, followed by a statewide sanitation code. Caldwell's slogan was "Genuine Mexican food, properly prepared," an obvious allusion to the concerns with food hygiene.

Felix worked hard, taught himself English on the job and eventually became the restaurant manager. Caldwell encouraged Tijerina to open his own business, so, in 1929, Tijerina opened the Mexican Inn on Main Street, which he operated with Antonio Reynaga. In 1933, he married Juanita "Janie" Gonzalez. In 1935, his restaurant went out of business, a victim of the Great Depression. Felix and Janie moved in with her mother on Center Street while he went to work for fifty dollars a week as a beer truck driver and salesman for Texas Old Union Company, handing over his pay to his wife until they had saved enough money to open another restaurant. With their savings and Janie's winnings from a bet she placed on a horse at Epsom Downs, he was able, in 1937, to find a suitable location at 1220 Westheimer Road in Montrose and open the eponymous Felix's Mexican Restaurant. It was a simple, white, one-story building across from the new Tower Theater. With the help of his friend Mingo Villareal and his wife, Felix managed to furnish the space and decorate it with Mexican curios. In addition, Janie offered other souvenirs for sale at the front of the restaurant. Villareal became his general manager. Felix took a gamble in opening a Mexican restaurant for Anglo customers right in the heart of Anglo Montrose, not too far from affluent River Oaks and West University. Before this, Mexican restaurants were relegated to the barrio. The flagship restaurant opened at 904 Westheimer Road in 1948, and dinner at that time cost fifty cents.

Mexican restaurants were among the early places where Anglos and Mexicans interacted, and the food they served was Tex-Mex, appealing primarily to Anglo tastes. This term first came into the English language as a nickname for the Texas Mexican Railway and was first used in connection with food in a *New York Times Magazine* article in 1963. The term later became popularized when Diana Kennedy used it in her 1972 book *The Cuisines of Mexico*. It was an expression used by Texans of Spanish descent, the Tejanos, to describe a mix of Mexican and Spanish food. Today, the food contains some Mexican ingredients but is characterized by heavy use of shredded cheese and spices such as cumin, which has its origins in Berber cooking and was brought to Texas by Spanish immigrants from the Canary Islands. The old Tex-Mex restaurants are still around—although authentic Mexican cuisine is gradually edging them out as people's tastes are changing. Now

Tex-Mex establishments tend to be frequented by older people driven by nostalgia as well as by families, including youngsters with sensitive palates. When our daughter, now an intrepid and ever-curious foodie, was a little girl, she loved few things more than "chippies and cheese" (nachos), be it at a Tex-Mex restaurant or at the counter of the now-defunct Fiesta Mart on the corner of Wirt Road and Longpoint Road. Felix was famous for chile con queso, cheese enchiladas and spaghetti with chili.

By the early 1950s, Tijerina and his family owned four restaurants in Houston, and at the peak of his success, Felix Tijerina owned and operated six Felix Mexican American restaurants in Houston and Beaumont. He owed some of his success to his general manager, Mingo Villareal; Daniel Sandoval, his assistant manager; and Florine La Rue, supervisor of the Westheimer location. For a while, his sister, also named Janie, worked there, and his wife became more and more involved in the running of the restaurants. Meanwhile, Tijerina became involved with Mexican American groups, eventually becoming president of the Houston chapter of the League of United Latin American Citizens (LULAC). He was elected twenty-fifth president of National LULAC and served four terms in that position. In addition to his concern for educating the Mexican American community on their political rights and responsibilities, he never forgot his own struggles and efforts to learn English. He took particular interest in the preschool education of Spanish-speaking children, establishing what would later become the model for the federal Head Start Program: the Little School of the 400, established in 1957. Its mission was to teach Spanish-dominant preschool children a speaking vocabulary of four hundred basic English words so that they could overcome the language barrier and have a successful start to kindergarten. Tijerina was invited to the LBJ ranch to discuss this and other educational programs with Lyndon Johnson, who would later incorporate them in his Great Society concept. Tijerina continued his financial support of the Little School of the 400 as well as his work with LULAC and the Rotary Club. He was also on the board of the Montrose National Bank. In 1979, the Houston Independent School District named an elementary school after him.

When Felix Tijerina died in 1965 at the age of sixty, Richard Nixon wrote a letter of condolence to his widow, saying, "Men with the courage, resourcefulness, leadership and, most important of all, feelings for others, that he possessed, are all too few in our times." Tijerina's wife, Janie, ran the restaurants until she died in 1997. The iconic Felix Mexican Restaurant served its last combination plate in 2008. Afterward, Scott Sullivan of the

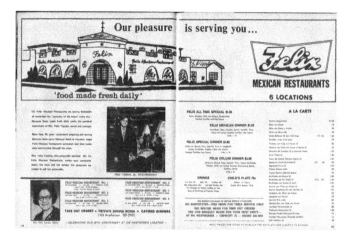

Dining Out in Houston, vol. 7, 1972. *Hospitality Industry Archives, Hilton College, University of Houston.*

El Patio restaurants bought the license for Felix's name and recipes. As a result, Felix's famous chile con queso is an item found on every El Patio menu. The space lay dormant for a few years until Tyson Cole opened an outpost of his Austin restaurant, Uchi, in 2012.

Felix's Chile Con Queso

½ cup flour
1 cup water
¾ cup vegetable oil
1 small onion, chopped
½ cup canned tomatoes
¼ cup paprika
1 pound American cheese, grated
1 pinch of salt
½ teaspoon cayenne

Stir together flour and water to make a paste. Set aside. In a saucepan, heat the oil. Add onion, tomatoes and paprika and sauté 5 mins. On very low heat, add the flour paste, stirring constantly for about 5 minutes. Add cheese, salt and cayenne. Stir until melted. Serve immediately.

THE GREEN PARROT

(1952–67)

2314 MacGregor Way

Also in Wichita, Kansas, and Kirkwood and

Kansas City, Missouri

Tena May Dowd opened the first Green Parrot Inn at Wichita, Kansas, in 1925, and a second location in Kansas City in 1929. In 1936, Tena May and her brother, J.H. Toothman, opened the Green Parrot Inn in Kirkwood, Missouri, near St. Louis, and in 1952, she and her sister, Vira B. Fredericks, opened the fourth location of the family-run restaurant in Houston.

Tena May became a cook out of necessity, assuming the role of running the family household and looking after her younger brothers and sisters when her mother died when Tena May was just thirteen years old. Tena May started the restaurant to keep busy after her two sons entered high school. She translated her love of cooking to the home-cooked meals she served at the Green Parrot Inn. The name of the restaurant came from the family parrot that lived in a cage in the lobby of the Kirkwood location.

The Green Parrot in Houston was owned and run by Tena May's sister Vira Fredericks. It was located in a large Colonial-style two-story mansion a few blocks east of Almeda in the MacGregor/Riverside area. It opened in 1952 and lasted until 1967, when the Texas Highway Department bought the property for the extension of Highway 59. The family-run restaurant

The Green Parrot. The back reads, "The Green Parrot of Houston, Tex. Is internationally famous for its delicious fried chicken and K.C. Steaks. Located one mile due East of the Warwick Hotel, in a beautiful Southern Mansion. Mrs. Vira B. Fredericks, Claude Fredericks, Jr." *Authors' collection.*

was famous for home cooking—what we would call comfort food today. The specialty was pan-fried chicken with mashed potatoes and gravy and vegetables served from family-sized bowls. The Green Parrot was also celebrated for the meatloaf, shrimp, Kansas City steaks and catfish. Desserts were always some sort of homemade pie or cake. One dish that almost everyone who dined there remembers was the Congealed Pear Salad, made in a mold, with Hawaiian cream dressing. Today we might consider this retro, but at the time, food prepared in a mold was all the rage. You can find many of Tena May's recipes in a book titled *Famous Green Parrot Recipes.* Later you will find her famous fried chicken recipe published from this book. Recipes for biscuits, yeast rolls, cinnamon rolls, gingerbread, corned beef hash, chicken pie, roast turkey and dressing, congealed salads, green bean casserole, strawberry shortcake and mile-high cherry chiffon pie are among the many recipes you will find in this wonderful collection of vintage recipes.

"The Green Parrot Inn was *the* place to go after church on Sundays," said Ann Criswell, the retired food editor for the *Houston Chronicle.* In 1967, the family sold the name, recipes and goodwill to Mike Lewis, who was reared in the restaurant business. He moved the restaurant to 4009 Bellaire

Boulevard. By 1984, the restaurant had moved again to the terrace level of the River Oaks High Rise at 3435 Westheimer. This location was run by Pat Jesselson, the niece of Vira Frederick. The name was changed to the Oaks Restaurant and a *Texan* advertisement from April 4, 1984, told us what to expect: "Announcing the re-creation of the original Green Parrot menu, featuring family-style dinners from the original recipes along with many of the original staff." Since many of the residents of the building were older Houstonians who probably remembered the original restaurant, it seems as though they had a built-in customer base. Recently, the building that housed the restaurant was completely gutted, and it is still under renovation.

Green Parrot Fried Chicken

For Green Parrot fried chicken you should have a chicken which weighs about two pounds after it is dressed and cut up. You will also need a heavy, cast aluminum skillet—not an iron skillet, but an aluminum skillet.

Fill the skillet about one-third full of pure lard, and let it heat just to a "sizzle." Have your chicken cut up, and ice cold. Dredge each piece well with salt and pepper, roll in flour, and place in the skillet. Do not crowd the pieces. Cover the skillet tightly, turn the fire as high as you can, and cook for ten minutes. At the end of ten minutes, look at the chicken, and if each piece looks brown around the edge, turn quickly and recover the skillet, and cook to a golden brown.

Do not take each piece of chicken out of the skillet when it is browned, but pick up the skillet and drain the grease off before you take up the chicken. This will keep your chicken from being greasy.

Chicken may be kept hot in a very slow oven while gravy is made from the chicken fryings, but it should not be covered tightly enough to cause it to steam, as this will make the crust soft and spongy. Green Parrot fried chicken is always a golden brown, and tender, yet crisp.

Do not substitute vegetable shortening for the pure lard, and be sure your skillet is at least one-third full of lard before you start to cook your chicken.

From Mrs. J.B. Dowd. *Famous Green Parrot Recipes*

THE GROOVEY GRILL

PRINCE'S HAMBURGER BAR, ELGIN AVENUE (1942–47)
THE GROOVEY GRILL, TIERWESTER STREET AND WHEELER AVENUE
(1947–67)
2619 CALUMNET STREET (1967–92)

Faurice and Jesse Prince met at Prairie View A&M University and moved to Houston in 1932. In a *Houston Chronicle* article on September 1, 1987, Jesse explained how they got into the restaurant business: "Across from the Forward Times, there was a Dairy Cup, where Blacks had to go to the back to get an ice cream cone. I said to myself that one of these days I'm going to have a [*sic*] ice cream parlor so I won't have to go to the back"

In 1942, Faurice and Jesse opened a hamburger stand on Elgin, called Prince's Hamburger Bar, catering to students from Jack Yates High School. Jesse was the head cook. In 1947, they moved to a larger location on the corner of Tierwester and Wheeler and changed the name to the Groovey Grill. This was at the time when Texas Southern University was founded (1947), so the Princes realized they were sitting on property with a large potential. Students and faculty started arriving, and as Jesse said, "That's when it really started swinging. Meet me at the Groovey Grill was the slogan around the community." The Princes never had children of their own, so they adopted many a TSU student, helping them out financially, providing jobs, contributing to scholarship funds and offering advances on their food.

For many students, Faurice and Jesse were just like family. In 1967, they moved to an even larger location, a two-story mansion in Riverside Terrace on 2619 Calumnet Street in the Third Ward, where the interior was left to look like the home it used to be. The Princes ran the restaurant downstairs, and they lived upstairs. That is where they remained until the Groovey Grill closed in 1992. Jesse supervised the kitchen staff and waitresses while Faurice manned the cash register.

Faurice and Jesse opened the Groovey Grill when segregation was in full force. It was one of the few places where African Americans could eat out without fear of intimidation or being threatened. Faurice Prince told a reporter for the *Houston Chronicle* on June 18, 1992, "There were very few restaurants in Houston at that time that catered to Blacks. We opened it up so our people would have a place to go."

From day one, the Groovey Grill was more than just a restaurant. It was an integral part of the African American community of Houston. Faurice and Jesse lived by a simple credo: "We don't count the money as much as we count the friendship." By all accounts, the money came, but the friendships lived on. It became *the* place for the African American residents of Houston to see and be seen, and anyone who was anyone in the African American community dined there.

The fried chicken and soul food the Princes served became legendary. Many famous people dined at their establishment, including President Lyndon B. Johnson, Barbara Jordan, Muhammad Ali, Rodney Ellis, Hank Aaron, Willie Mays, Roy Campanella, Ray Charles, Jackie Wilson, Jim McConn, Mickey Leeland, Jesse Jackson and Senator Lloyd Bentsen.

The Groovey Grill sustained many a protester during the sit-ins against segregation that occurred in 1960. The protesters who staged Houston's first sit-in went to the Groovey after their successful protest at the Weingarten's lunch counter on Almeda to plan their next moves. The next protest occurred when protesters arrived at Mading's Drug Store a few days later. They were met with a "Fountain Closed" sign, and as soon as Jesse Prince heard about it, she brought them juice and donuts from the Groovey.

In 1992, a local attorney, Walter Strickland, purchased the restaurant and undertook an extensive renovation of the building and property, restoring it to its former glory. In 1998, Strickland was awarded a "Good Brick Award" by the Houston Preservation Alliance for the work he did. Today, it is known as the Groovey Grill Mansion and is an events facility and banquet hall available for weddings, receptions, corporate events and meetings.

HEBERT'S RITZ

(1939–87)
1214 McGowen Street

Clifton "Pappy" Hebert was born in 1898 in Napoleonville, Louisiana, between Baton Rouge and the Gulf of Mexico. From his beginnings in the restaurant business at Antoine's in New Orleans, Clifton dreamt of having his name on a famous restaurant. Little did he know it at the time, but when he and his wife, Lula, moved to Houston, they opened what was to become one of the city's most famous restaurants: Hebert's Ritz. Clifton called his restaurant "Houston's Rendezvous of the Bon Vivant." A sign out front read "Famous French Cuisine," and the Heberts were among the first to introduce Houstonians to Louisiana-style French food. The restaurant was originally called Ritz Café, but Clifton fulfilled his dream of having his name on a famous restaurant when he changed the name to Hebert's Ritz. To make it easier for his patrons to pronounce and remember the name, Clifton later added a sign on the street corner with the image of a polar bear wearing a sandwich board with the words "A-Bear! That's The Way You Pronounce It."

Hebert's Ritz started out as a steakhouse because Clifton believed that Texans only ate steak and potatoes. Clifton loved fishing so much that he slowly added seafood to the menu, and he became famous for his seafood offerings such as shrimp remoulade, shrimp *Ravigotte*, trout *almondine*, trout excelsior, trout *Meunière* and red snapper Pontchartrain.

The remoulade sauce was legendary, and many people contacted Ann Criswell at the *Houston Chronicle* to see if she could provide the recipe. In the end, three-quarters of the menu contained seafood dishes. Hebert's was also famous for preparing and serving the food with many different sauces. Sauce Roquefort, sherry wine and mushroom sauce, sauce *Bonne Femme* (mushrooms, green onion, garlic, chives) and sauce *Ravigotte* (celery, onion, dill pickle, egg, mayonnaise) were some of the many sauces Clifton prepared. A lot of the sauces used wine, something of a novelty for Houston at that time.

A menu from 1941 shows Steak *en Papilotte* (in a parchment paper sack) and Suzettes (crêpes suzette) "burned at table with brandy sauce," which was undoubtedly the first time these dishes had made it to Houston. I am not sure patrons wanted their crêpes burned. However, this is the term used on the menu. In the 1950s, when Clifton hired Chef Leon Baron from France, this news made it to the paper. It was said that "this is living proof that Houston has grown into a cosmopolitan center. For the discriminating people who know old-world French cuisine, he is the answer to a long-felt need." The article went on to reassure people that "French foods will be featured along with the café's well-known steaks," just in case anyone thought that Hebert's would no longer be serving steaks. In 1941, rib steaks cost between sixty and eighty cents, and if you wanted them served with a baked potato, it was five cents more.

When the Heberts first moved to Houston in 1939, they leased the Roosevelt Hotel Coffee Shop. Six months later, they purchased a small, eleven-seat sandwich shop on Fannin before moving into the large, two-story house on the corner of McGowen and San Jacinto in 1941. The Victorian mansion was built in 1904 and housed a Mexican restaurant before the Heberts moved in. The restaurant was downstairs, and the family lived upstairs. There was a private dining room in the basement with a well-stocked wine cellar. The upstairs living quarters were turned into the restaurant when the family moved next door. Full of antiques, dark wood paneling, fretwork, stained-glass windows, a large fireplace and the original gas chandelier, converted to electric, in the foyer, the place definitely had the feel of New Orleans' French Quarter.

In addition to the seafood, Hebert's specialty was rib steaks. The meat came from Chicago, where it was purchased especially for the restaurant. There is a picture of Clifton and his chef, Herman, at the Stockyard's Packing Company examining sides of USDA prime beef before it was shipped to Houston. All the meat was aged and cut on the premises. At

lunch, the corned beef and cabbage, red beans and rice and seafood gumbo were customer favorites.

Hebert's was blessed with a longtime staff and loyal customers, many of whom had been patronizing the restaurant for three generations.

Peggy Ryan, the Heberts's daughter, managed the restaurant after 1970, the year Clifton died. She redecorated the restaurant in 1980 but struggled to keep it going, and in 1987, the restaurant closed. The building was torn down shortly thereafter.

Hebert's Ritz Remoulade
(Makes About 1 Cup)

1 cup mayonnaise
1 tablespoon Worcestershire® sauce
1 tablespoon paprika
1 tablespoon mustard
2 tablespoons vinegar
¼ cup chopped parsley
4 green onions, chopped
1 teaspoon Tabasco® sauce
3 cloves garlic
2 hardboiled eggs, chopped

Process all the ingredients except the eggs in a blender or food processor until smooth. Stir in the eggs, if using.

JOE MATRANGA'S

JOE MATRANGA'S ITALIAN RESTAURANT (1947–90)
3700 IRVINGTON BOULEVARD

J oe Matranga was born in Houston in 1917, the second of eleven children of George and Annie Paratore Matranga, who came to the United States from Sicily in 1889 via New Orleans. Like many Italians in Houston in the 1930s, the family were farmers. In addition to working on the farm, Joe and his brothers worked at the docks in Galveston.

Joe went to Jeff Davis High School, where he played football and wrestled. After serving in the U.S. Navy during World War II on USS *Stoley* as a machinist, in 1947, Joe opened a beer and barbecue restaurant called the Ding-A-Ling. Along with his brother-in-law, Pete Palermo, he operated out of a single-story house on Irvington, on Houston's Northside. This area was home to a number of Italian families.

One day, as Joe and his family were enjoying a plate of spaghetti, three customers who worked at the mechanic's shop nearby were offered some, and they suggested that Joe should put the dish on the menu. A year and a half later, Joe bought out his brother-in-law and added Italian dishes to the menu. In 1954, the restaurant name was changed to Joe Matranga's Italian Restaurant, and he spent a lifetime making thirty-gallon batches of his famous red sauce.

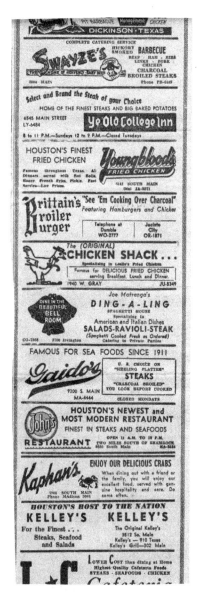

For many Houstonians, this was their first taste of Italian food. In the 1940s, Italian food was still quite exotic for Houston, but Joe developed a loyal following. His cooking was old-school Sicilian-style Italian American. Customers drove from all parts of Houston to eat Joe's famous spaghetti and meatballs with its thick, red sauce, which was known to everyone as *sugo*. Famous attorney Richard "Racehorse" Haynes celebrated every family occasion there. Politicians, judges and city officials all held court at Joe's. The interior of the place was intimate and dimly lit, with tables covered with red and white checkered tablecloths that became synonymous with Italian restaurants. Also on the tables were traditional flasks of Chianti holding candles dripping wax. In the back, the famous Bell Room accommodated two hundred people and served as an event space complete with a dance floor. Above the dance floor was a large bell—hence the name.

In his younger days, Joe was a bodybuilder and often posed for professional bodybuilding magazines. In 1941, while Joe was at a photographer's studio, he was shot posing as a Greek god. He was scantily clad in a loin cloth and made to look as though he was pierced through the back and heart with a spear. This photo, which was turned into a painting, hung on the wall at the back of the restaurant. Joe had the painting made into postcards that he signed and handed out to guests.

Under the painting was a sign that read "Eat a pound of pasta and you get it free." A newspaper article from 1952 informs us that someone actually accomplished this, telling us that "one guy did it in 45 minutes."

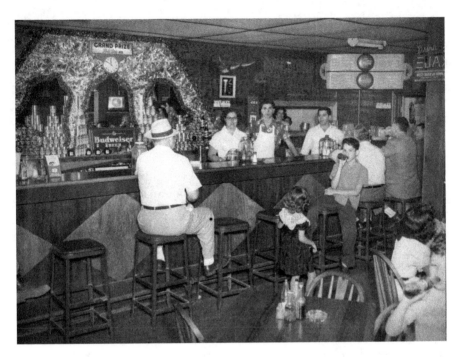

Above: Joe Matranga, in the white shirt, behind the bar of the Ding-A-Ling. *Courtesy of Theresa Matranga Neal.*

Opposite: Newspaper advertisement for the Ding-A-Ling. *Courtesy of Theresa Matranga Neal.*

Joe and his wife, Lena, had four children: Virginia, Mary Ann, Theresa and George. George worked at the restaurant for five or so years, and Theresa filled in occasionally when necessary.

The sauces and meatballs were all made by hand, and friends who were allowed "in the back" often saw Joe making the meatballs himself, always picking up the exact same amount from the pile and forming it with one hand. Joe could make a perfect meatball, while talking with his customers without losing eye contact or the thread of the conversation. People commented that they could smell the aromas of garlic, tomatoes and Italian spices as soon as they entered the restaurant and began to salivate in anticipation of the great meal they were about to have. Joe's food was always praised for being consistently good. In addition to his spaghetti, Joe also made an excellent veal Parmigiana, lasagna and cannelloni, and his meals all came with garlic bread and a salad.

In 1974, *Texas Monthly* pronounced Joe Matranga's food the best Italian in Houston. Joe's son, George, told me a story about when his father was

Menu from Joe Matranga's. *Courtesy of Theresa Matranga Neal.*

contacted by the food magazine *Bon Appetit*. The reputation of Joe Matranga's had come to the attention of the food editors in New York, and they desperately wanted to get Joe's sauce recipe. "My dad was old-school Sicilian and didn't trust anyone," said George. Despite George's assurance of the magazine's prestige, Joe just shrugged it off. In 1994, Joe was interviewed for an article that appeared in the *Houston Chronicle*. He was seventy-seven years old, and the restaurant had already been closed for four years, so the writer asked Joe for his recipe. He replied that his sauce contained "onion and garlic and olive oil and salt, pepper and basil—that's all I'll tell you." Elsewhere in the article, we find out it contained tomato paste and simmered for eight hours. The rest is lost to history. There was, however, one secret ingredient to his sauce that Joe did not reveal until very late in life. This is what he said: "The recipe is filled with many family secrets, but the main ingredient was always to prepare the sauce with love. It was the love of my beautiful wife and family that enabled me to make the sauce and roll meatballs with joy for all of those glorious years."

Joe loved everybody, and if you walked through the door of his restaurant, you were automatically his friend. Sometime during a meal, Joe would wander up to the table to talk to you or maybe tell you a joke, for he was quite the entertainer, no matter who you were. Above all, Joe always maintained his wonderful sense of humor. There are stories how in the early days, Mexican Americans living in Houston did not feel comfortable eating where non–Mexican Americans ate, but at Joe's, they felt right at home.

In addition to his culinary skills, Joe was an accomplished singer and loved to perform anywhere and everywhere. He had a beautiful, vibrant tenor and at one time performed at every Italian wedding (including his own in 1940) and other Italian celebrations. Articles in the newspapers of the times referred to him as the "North Side's Mario Lanza." (Mario Lanza was a popular Italian singer of the '50s.) Joe was also known as the "curly-haired Adonis of Irvington Boulevard" as well as "spaghetti man" and the "singing spaghetti king of Houston."

In 1990, just prior to Joe's retirement from the restaurant, Matranga's was honored as the "Oldest Italian Restaurant" in Houston. Joe was a giving man and often generously donated free pasta to a local school for its annual spaghetti dinner fundraiser. To his friends, he gave bottles of his pasta sauce every Christmas. When he retired, Joe volunteered at the weekly spaghetti lunch at the Sacred Heart Society. When the restaurant closed its doors for the last time in 1990, Joe had one thirty-gallon batch of red sauce left over. He gave it away to the staff, family, friends and longtime customers. Thereafter, he continued making it in his garage, in smaller, ten-gallon batches. It was the same recipe he had developed more than forty years prior while watching his mother cook, and his family and friends still enjoyed every batch he made. Joe spent his last years at St. Dominic's Residence Center, where he died on May 17, 2013, at the age of ninety-five. As one of his many fans said about him in his obituary, "You know God is eating well now."

KAPHAN'S

KAPHAN'S RESTAURANT AND CLUB 7900 S. MAIN STREET (1927–97)

RENDEZVOUS ROOM, SOMMELIER ROOM, RED ROOM,
COTILLION BALL ROOM, CHARCOAL GARDEN

Kaphan's Restaurant was founded by Eli Kaphan, a baseball player from Galveston who played for the Texas League until 1921, when an ankle fracture ended his career as an athlete. He never lost his love for the game, however, as he became an umpire and a collector of baseball memorabilia.

After several false starts in the restaurant business, he bought a cow pasture on Main near the Astrodome. In 1927, he opened an oyster shack there before building a restaurant on the property. It was a single-story, modern-looking building opposite what was to become the Astrodome and Astroworld. The entry to the restaurant was located at the same spot as one of the original cattle troughs. At the time, a trolley line used to run from this area to Richmond, Texas, and the area in front of the restaurant was the trolley's turning point.

Kaphan's was originally called "The Aristocrat of Seafoods." It was known for its slogan: "If it swims, we have it." Sometime later, the word "Steaks" was added to the moniker and "Seafoods" was changed to "Seafood." In a print advertisement from the period, readers were recommended to "See the World Series gold bats. A one-of-a kind collection," referring to the baseball

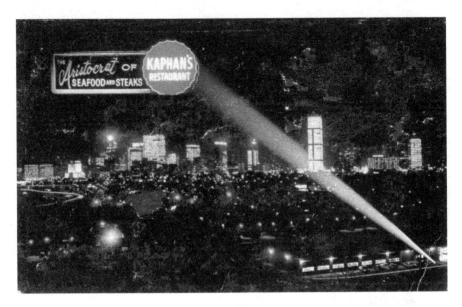

Kaphan's Restaurant. The Aristocrat of Seafood and Steaks. The back reads, "A favorite with gourmets, noted for its fine foods and elegant surroundings. This distinguished restaurant is famous for its seafoods and other festive holiday specialties. Air-conditioned. Charcoal Garden acclaimed as one of the most attractive and unique dining areas along the Texas Gulf Coast." *Authors' collection.*

Kaphan's restaurant interior. *Authors' collection.*

bat collection and other memorabilia that Kaphan owned and displayed in the lobby. In its heyday in the 1970s, Kaphan's was the epitome of an upscale Gulf Coast seafood restaurant.

After Kaphan's death, the Petkas family purchased the restaurant in 1943. In the 1950s, Pete Tomac bought into the restaurant, and he brought along his younger brother, Arnold John Tomac, who ran the kitchen. The Tomacs were of Croatian heritage but born in Kansas. Nick Petkas and his elder brother James P. Petkas also owned Captain John's restaurant, and in 1962, Nick started Nicky's Restaurant on Kirby at Westheimer.

A 1950 menu showed the breadth of the Kaphan's offerings and how tastes have changed since that time. Appetizers included tomato juice ($0.25), fruit cocktail ($0.50), filet of imported anchovies ($0.75) and olives—green, ripe and stuffed ($0.35). Frog legs ($2.00) could be found under fish dishes, as could escalloped oysters or *en brochette* (six for $0.85). Main courses included KC steaks ($2.25–$3.25) and Kaphan's Golden Fried Chicken ($1.25). Calf's liver with bacon or onions ($1.35) and Lobster Thermidor ($2.75) were also available. Kaphan's was most famous for its oysters. One of the special oyster dishes was listed on a marquee outside the restaurant: "Dichotomy of Oysters." It consisted of three each of four differently prepared oysters: oysters Rockefeller, oysters diablo, Ernie's oysters and oysters à la Kaphan's. The menu suggested that diners eat the oysters in counterclockwise succession on their platter "because of ascending flavor." Pete Tomac used to move through his domain, the dining room, with a silver platter offering samples of oysters à la Kaphan's on toothpicks. As soon as patrons were seated, they were served complimentary garlic toast and crab balls.

Kaphan's also offered a kids' menu. On the front was an illustration of a clown's head. Inside there were illustrations of six animals, and young patrons were asked to order by animal. For eighty-five cents, children could order the Bear, which consisted of pineapple juice, French fried shrimp, tartar sauce, fried potatoes, green vegetables, hot rolls and butter, milk and ice cream.

A downturn in the Houston economy in the mid-1980s—along with increased competition, changing demographics and shifting eating habits—forced many restaurants to close their doors. Kaphan's customers, like the wait staff, were loyal but aging. They were the regulars, who sat at the same table, who did not order from a menu and whose wishes the waiters knew in advance. Above all, they wanted comfort, consistency and nothing new-fangled. Tomac described them as "an older clientele

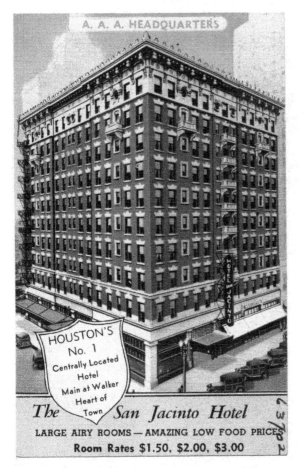

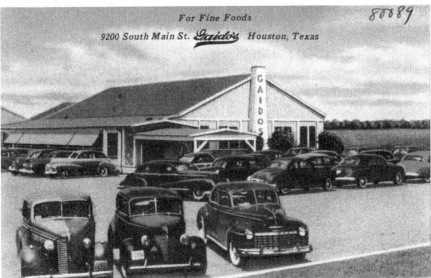

Left: The San Jacinto Hotel. *Courtesy of the Trustees of the Boston Public Library.*

Below: Gaido's. *Courtesy of the Trustees of the Boston Public Library.*

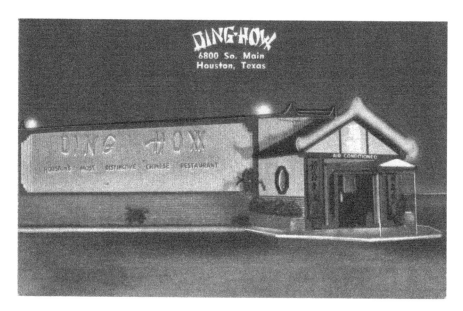

Ding How. *Authors' collection.*

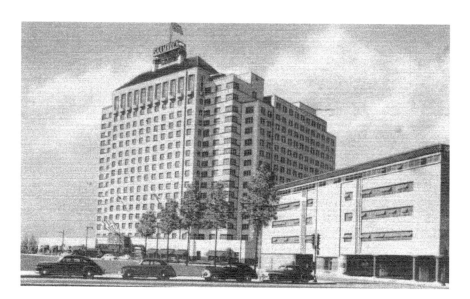

Shamrock Hilton. *Authors' collection.*

The Ship Ahoy—Houston's Most Exclusive Restaurant. *Authors' collection.*

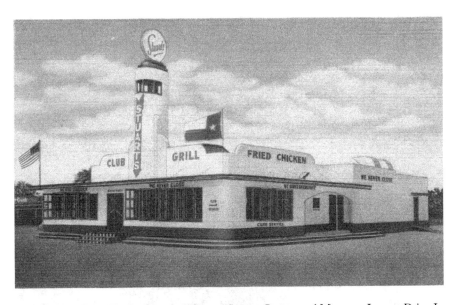

Stuart's Club Grill. The back reads, "'Sonny' Stuart, Owner and Manager. Largest Drive-In in the Southwest. We Never Close. Curb and Dining Room service. Featuring Sea Foods, Chicken, Steak and Special dinners." *Authors' collection.*

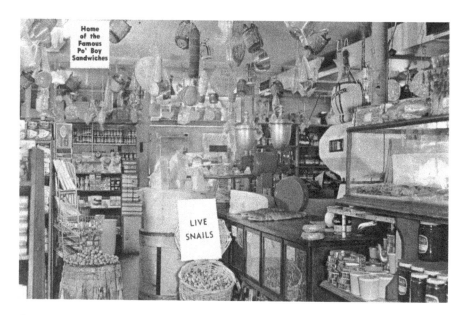

Original Antone's Import Co. location on Taft Street. *Authors' collection.*

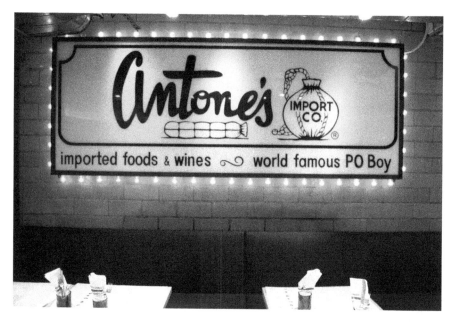

Photo of original Antone's Import Co. sign that hung in the store on Taft Street; it now hangs in Pass & Provisions restaurant. *Courtesy of Ralph Smith Photography.*

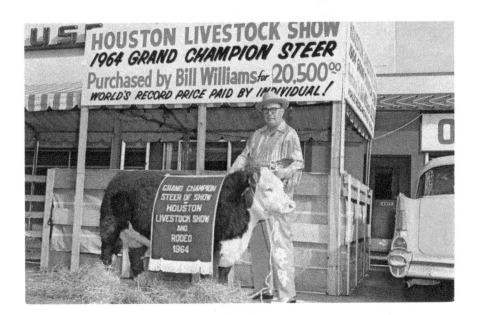

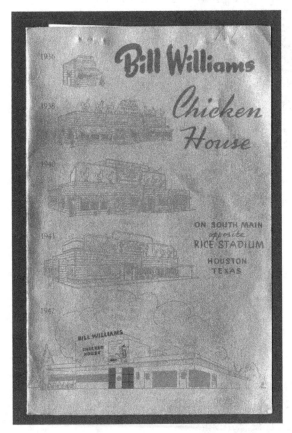

Above: Bill Williams with one of the many champion steers he purchased for charity at the Houston Livestock Show. *Authors' collection.*

Left: Bill Williams Chicken House menu, 1946. *Annette Gano scrapbook, Rice University scrapbook collection, box 6, UA 230, Rice University Archives, Woodson Research Center, Fondren Library, Rice University.*

Above: Felix Mexican Restaurant. The back reads, "The new Felix Mexican Restaurant is now able to accommodate 325 patrons at one time. Located in Houston, Texas at 904 Westheimer." *Authors' collection.*

Left: The Peacock Grill. Dining Room. Bar & Grill Room. *Authors' collection.*

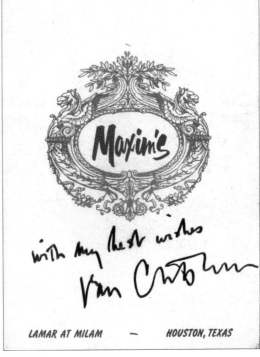

Above: Maxim's menu after the move to Lamar Street. *Camille Bermann-Maxim's Collection, Hospitality Archives, Hilton College, University of Houston.*

Right: Maxim's menu signed by Van Cliburn. *Camille Bermann-Maxim's Collection, Hospitality Archives, Hilton College, University of Houston.*

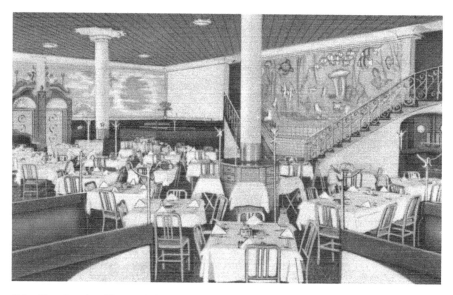

Ship Ahoy interior. Houston's Leading Restaurant. Near Shamrock Hotel. HY. 90. *Authors' collection.*

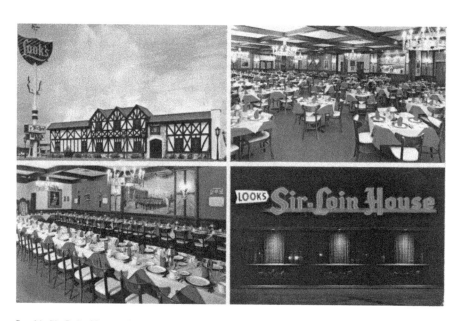

Look's Sir-Loin House. *Authors' collection.*

The Green Parrot. *Authors' collection.*

Pig Stand #7, 2412 Washington Avenue. *Courtesy of Emily Schwenke.*

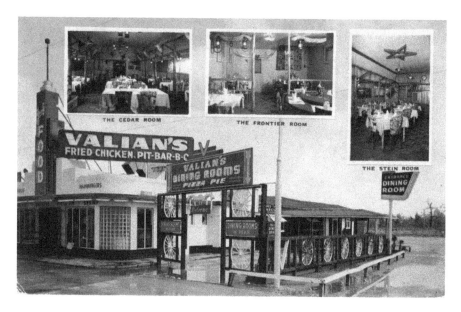

Valian's restaurant postcard. The back reads, "Opposite the Shamrock Hilton Hotel. Delicious Filet Mignon—Sea Food—Spaghetti—Bar-B-Q. Famous For Our PIZZA." *Authors' collection.*

Part of Vargo's grounds and lake. *Courtesy of Tim Stanley Photography; copyright Tim Stanley.*

A peacock in full display on the Vargo's property. *Courtesy of Tim Stanley Photography; copyright Tim Stanley.*

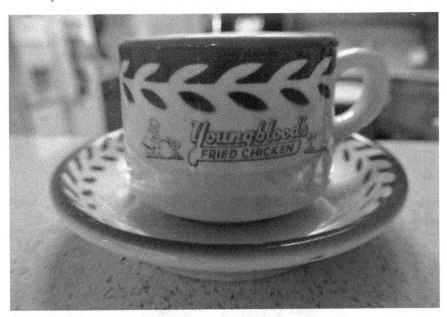

Youngblood's Fried Chicken dinnerware. *Photo by Paul Galvani.*

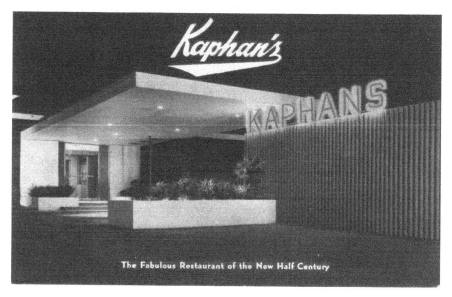

Kaphan's: The Fabulous Restaurant of the New Half Century. The back reads, "The fabulous restaurant of the new half century. Famous for Seafoods throughout the U.S.A. First in French Fried Shrimps. Catering to Private Parties. Private Dining Rooms. Newest Air Conditioned Eating Place in Houston, seating 450 Persons. Pay us a Visit." *Authors' collection.*

Groovey Grill Mansion. *Courtesy of J&L Photography.*

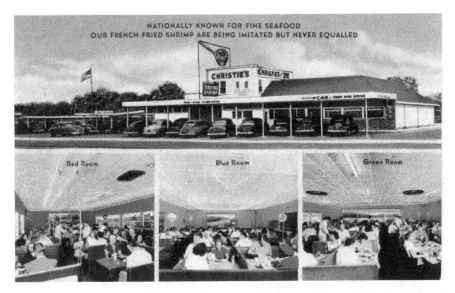

Christie's. Nationally known for fine seafoods. The back reads, "Established 1918. Three air conditioned dining rooms, seating capacity 360 persons, serving nearly 750,000 satisfied customers. Over half million pounds of assorted seafoods including 200,000 lbs. of jumbo Gulf shrimp served as French Fried. Our French Fried shrimp are being imitated but never equaled." *Authors' collection.*

The Yale St. Grill, opened in 1923, part old-time diner, part gift store, is one of the only original diners left in Houston. *Photo by Paul Galvani.*

Lankford Grocers, opened in 1939, where you can still get a great hamburger. *Photo by Paul Galvani.*

Cream Burger dates from 1946. It is a small hamburger stand near the University of Houston that still serves up no-frills hamburgers. *Photo by Paul Galvani.*

Moeller's Bakery opened in 1930 and still serves irresistible orange-glazed sweet rolls. *Photo by Paul Galvani.*

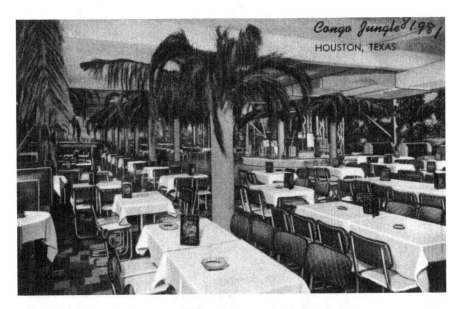

Congo Jungle, 5704 Almeda, was one of Houston's hot nightspots from 1946 until the early 1960s. It featured a jungle motif—complete with palm trees and waitresses outfitted in leopard-print dresses. *Courtesy of the Trustees of the Boston Public Library.*

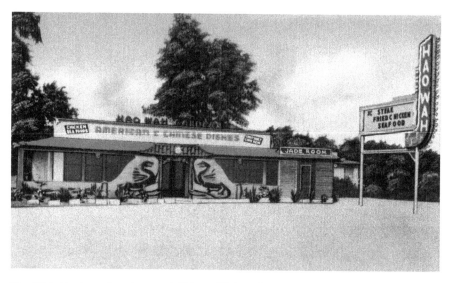

Hao Wah Gardens. American and Chinese Dishes. *Courtesy of the Trustees of the Boston Public Library.*

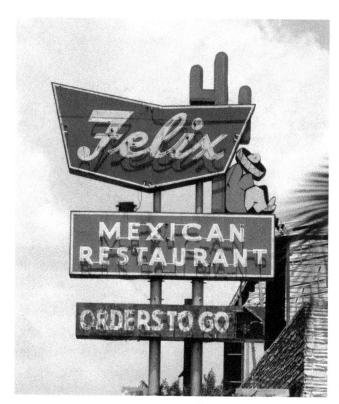

The iconic sign outside Felix Mexican Restaurant on Westheimer. When the restaurant closed in 2008, Houston went into mourning. *Photo by Angela Orlando; www. flickr.com/photos/ maorlando.*

that favors peace and quiet." One writer noted that "at most restaurants, patrons call to make reservations. At Kaphan's, they call when they aren't coming." However, it was simply not a place for young professionals. In August 1995, an article in the *Houston Chronicle* announced that Kaphan's had been losing money since 1988 and Pete Tomac would entertain any offers. One offer came from Samuel Robinson, who planned to turn half of the building housing Kaphan's into a topless club called Rembrandt's Cabaret. Tomac planned to continue to operate a catering business in the other half of the building. There was an outcry from the community, and by the end of October of that year, after much opposition from local businesses and residents, the plans were scrapped.

Oysters à la Kaphan's

24 oysters
Salt, pepper
Flour
3 tablespoons butter
1 cup A-1® Steak Sauce
2 tablespoons Worcestershire® sauce
¼ cup dry sherry
2 tablespoons water
3 tablespoons flour

Season oysters with salt and pepper, then dredge in flour and sauté in 1 tablespoon butter until crisp and browned on both sides. Remove from pan, then melt remaining butter. Add the next 3 liquid ingredients and heat through. Blend 2 tablespoons water with 3 tablespoons flour. Stir into sauce. Pour sauce over oysters.

MAXIM'S

(1950–2001)

707–9 Fannin Street (1950–58),
formerly the Peacock Grill

802 Lamar Street (1958–81)

3755 Richmond Avenue (1981–2001)

Camille Bermann was born in Luxembourg in 1917. He moved to Brussels at age fourteen, learning to make pastries in a pastry shop. Then, when he was sixteen, he moved to Paris, where he started out as a waiter at the Ritz Hotel. His training included being under the famed French chef Georges Auguste Escoffier. Bermann claimed that he was Escoffier's last student. In 1939, at the age of twenty-two, he left France and came to New York with Henri Soulé, working at Le Restaurant Du Pavilion de France at the French pavilion of the New York World's Fair. His cabin mate for that momentous journey from France to the United States was Salvador Dalí. At the end of the 1939 World's Fair, he went to work at La Cremaillière in New York. While there, in 1945, he met Frank Costello, a noted mafia crime boss, who invited him to New Orleans to run the Beverly Country Club, whose patrons were more interested in gambling than eating. In 1946, Bermann left New Orleans and moved to Galveston, where he became the general manager of the Balinese Room, a nightclub famous for

illicit gambling. It was built on a pier that stretched six hundred feet into the Gulf of Mexico and was designed in a maze-like fashion; in the event of a raid, it would take the maximum amount of time to move from the entrance to the back of the house, where the gambling took place. Mark Bermann, Camille's son, explained Camille's role: "Camille was at the entry in the front and in the event of a raid, he would press a button warning the staff in the back to drop any incriminating evidence through holes in the floor under the tables and out to sea." Bermann moved to Houston in 1948, when he met Max Manuel and Nick Spanos, two Greek immigrants. In 1949, the three of them took over the Peacock Grill on Fannin Street. In 1950, Camille changed the name to Maxim's after the world-famous Parisian restaurant Maxim de Paris. Bermann chose the name Maxim's because he felt that this represented the epitome of class.

When Maxim's appeared on the restaurant scene, Houston was considered a "provincial outpost as far as fine dining is concerned," according to one writer, who went on to say, "Overnight millionaires got a quick course in how not to embarrass themselves when confronted with three forks to the left of the dinner plate. Well-travelled Houstonians found a restaurant to equal those they knew in New Orleans and New York." The restaurant's décor was unlike that of any other Houston restaurant. It was opulent—almost gaudy—with red velvet–flocked wallpaper, large chandeliers, paintings and statues throughout. Some people even likened it to a French bordello. The food was foreign, the menu written in a language few understood, the use of wine sauces was unfamiliar and the wines were new to Houstonians.

What prepared Houston for the influence of French cuisine? In 1934, two brothers, Marcel and Conrad Schlumberger, opened an office in Houston of their oil field services company. Conrad's daughter, Dominique, married Jean de Menil, a businessman and banker, in 1931, and moved to Houston around 1939, at the onset of World War II. Once they discovered Maxim's, they became regular customers and introduced their friends in the oil industry to French haute cuisine. Jean, who officially changed his name to John in 1962, when he became a U.S. citizen, went on to become president of two divisions of the Schlumberger.

Camille was a perfectionist when it came to anything to do with the restaurant and the way it was run. Ronnie Bermann, Camille's other son, remembers how his father used to line up the waitresses every day and check their uniforms and their nails. This sort of attention to detail ensured that the staff knew what Mr. Bermann expected. In his book *Press Releases*, Ted Roggen, a longtime Houston public relations professional,

relates a story of when he was allowed to listen in on one of Camille's daily briefings to his staff. Here's what he wrote of one of those briefings: "Joseph, you did not fill Mr. Haynes's glass of water. Sally, you failed twice to empty Mrs. Elkins' cigarette holder and Raphael, you forgot to bring more bread to the Adams table."

Camille was notorious for berating his staff in public, but some have said that this was a ruse to get the customers to empathize with the staff, thus increasing the size of the tip. Judging by the fact that Maxim's had very little turnover in staff, this may well have been true. Maxim's, probably more than any other restaurant in Houston, was responsible for introducing generations of Houstonians to haute cuisine and especially wine. According to Bill Roberts, writing for the *Houston Chronicle* in March 1986, "He [Bermann] would change Houston's eating habits. He taught us to eat snails!" The list of other items Bermann introduced to Houstonians included *foie gras*, pâté, caviar, escargots, crêpes, steak tartare, lobster bisque, lobster Thermidor, Belgian endive, *crème brûlot* and baked Alaska. Bermann, ever the showman, was aware of the importance of the spectacle when it came to the preparation of food, and Maxim's became famous for the tableside preparation of dishes such as steak tartare and Caesar salad. The dining room also had a cart on which the roast beef was carved and another roaming cart for hors d'oeuvres. Other dishes were either finished tableside, like the de-boning of fish or the opening of fish *en papillote*, cooked tableside, like pepper steak, or sliced tableside, like the Chateaubriand. Servers also used to flame the baked Alaska and bananas Foster at the table. This sort of spectacle and dramatic presentation only enhanced the mystique of the restaurant and caused patrons to look at what others were ordering and, intrigued at what they saw, perhaps order the same. As for wine, Maxim's had the largest cellar in Houston, housing between seventy and eighty thousand bottles.

In later years, it became the norm to honor famous patrons who dined at restaurants by having a dish on the menu named after them. The crab and shrimp Charlie Bell salad mixed with the house dressing and *rémoulade* was one such dish (Bell was a former chairman of Tennessee Gas). There was also the Schlumberger salad for Pierre Schlumberger, made with romaine lettuce, sliced avocado, eggs and tomatoes with house dressing, and the salad Halbouty, named after famed wildcatter Michel Halbouty, founder of Halbouty Oil, which consisted of lump crabmeat with artichoke hearts, finely chopped onion and house dressing.

A menu from the early days indicates that the restaurant already had valet parking of sorts. The menu stated the following: "Doorman will park your

car. No charge." At the top of the menu was a rhetorical question: "A dinner without wine?" Various answers were scattered throughout the rest of the menu: "Is like a humorist without wit; is like a lion without courage; is like a hunter without shells; is like a heart without love; is a criminal offence." This was certainly a not-so-soft sell to encourage wine sales and make patrons feel guilty about not ordering it.

In 1958, Bermann moved the restaurant to the Foley's Department Store garage building on 802 Lamar at Milam, where it remained for twenty-three years. In 1960, the building on Fannin that housed the first Maxim's was demolished. Then, in 1981, Camille moved the restaurant to a ten-thousand-square-foot building in Greenway Plaza following a decline of the downtown area and a significant increase in rent in the downtown location. Mark Bermann told us how this move occurred: "Ken Schnitzer was jealous of developers like Gerald Hines and Steve Chase because they had developments with fine-dining restaurants like Tony's. Ken wanted something similar." Schnitzer was the developer responsible for Greenway Plaza and the Summit. He told Bermann that he would design the entire restaurant for him, inside and out, free of charge and offered him the location rent-free. His only stipulation was that Bermann could have nothing to do with any part of the design and he had to run a world-class restaurant there. Camille jumped at the offer. A California designer called Steven Chase was picked by Schnitzer to do the job. On all accounts, it was a beautiful and sumptuous interior with a luxurious entryway with beveled-glass entry doors, Chinese urns and Romanesque sculptures, a pink and green color scheme, oversized mirrors, Impressionist paintings and marble-tiled restrooms. "Dad used to complain about the ladies' bathroom, saying that it was so large, he lost eight to ten tables," Mark told us. On their first tour of the restaurant, Ronnie remarked, "While the place was gorgeous, the kitchen was not functional and I told them this. Dad and Ken were not happy that I spoke up but Dad knew I was right. It took us a long time to make the adjustments we needed to make it right."

During the oil boom of the '70s and '80s, many a deal was struck in the dining room of Maxim's. It was home to Houston's movers and shakers. Bermann was considered both colorful and fast-talking. He got the nickname "Frenchie" because of his accent, even though he was not French. For many years, Maxim's was the only downtown fine-dining restaurant also open in the evening. Ronnie Bermann told us how lunch at Maxim's was hectic and crazy. "We did three turns at lunch: 11:30–12:15, 12:15–1:30, with mainly business people, and at 1:30, the women who shopped came in to dine. This

was only possible because of the efficient staff who did not rush the patrons, but let's just say, they moved things along."

In 1991, at age seventy-four, Camille died; he is buried in Emanu El Cemetery. His son Ronnie took the reins and maintained many of the dishes that made Maxim's famous but tried to modernize some of the cooking techniques from very traditional French methods that were heavy on the wine/cream sauces. Ronnie introduced blackened seafood, since this technique was just being popularized by Chef Paul Prudhomme in his K-Paul's Louisiana Kitchen restaurant in New Orleans. In 1998, Ronnie noticed that some of his customers were stopping by to eat before and after a Rockets game at the Compaq Center, just around the corner from his restaurant, so he created Spider's in one of the bar areas for those patrons who chose not to wear a suit and tie. It was dubbed Houston's first white-tablecloth sports bar. In those days in Houston, it was still de rigueur to dress up for dinner at a fine-dining establishment. Ronnie played traffic cop in the lobby of the restaurant, directing customers to either the main dining room or Spider's, depending on how they were dressed. One year later, Ronnie bemoaned that "we no longer require coats and ties." Some of his customers complained that things were going downhill because of this.

In 1999, when the world caught Y2K fever, retrospectives could be found everywhere. In that year, *Texas Monthly* named Maxim's "Restaurant of the Century" in its "Best of the Century" issue for bringing "culinary sophistication to the state's largest city."

In 2001, Ronnie sold the restaurant to the Pappas Bros. It was to be the Pappas Bros.'s first French restaurant. In 2002, Chris and Harris Pappas still had plans to "bring the fine-dining establishment into the present with new fixtures and a chef-driven menu." Those plans, however, failed to materialize, and in 2003, Pappas Bros. sold the Maxim's name to an individual who opened Maxim's European Restaurant on Memorial Drive. It remained open for only a brief period. In 2004, the building in the Greenway Plaza that housed Maxim's was demolished. In its place was to be the new, reinvented Tony's, which Tony Vallone moved from the Galleria area.

After selling Maxim's, Ronnie ran a catering service with Jeff Jamail called J&R Catering that offered many of the signature dishes that made Maxim's famous. They catered dinners for up to one hundred people. He also made and sold Maxim's famous Greek carp roe spread *tarama salada*, which became known as "Greek caviar" and was served as a complimentary appetizer at the restaurant. It is still available at the Phoenicia Market downtown location. The story of how this *tarama salada* was served as an

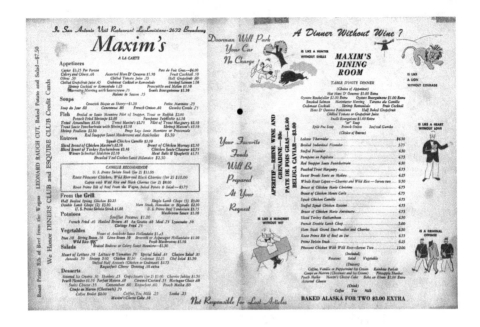

Maxim's menus; above from 1958, below undated. *Camille Bermann-Maxim's Collection, Hospitality Archives, Hilton College, University of Houston.*

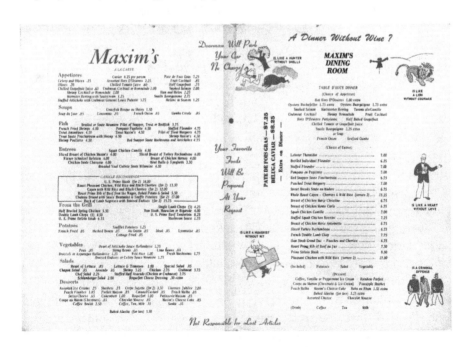

Ronnie Bermann still sells his famous tarama salada, known as "Greek caviar" in Houston area supermarkets. *Photo by Paul Galvani.*

appetizer goes back to Camille's first restaurant in Houston, the Peacock Grill, where it was served as a spread. Camille picked up on the idea, and it became a trademark of the restaurant until the very end. Camille's wife, Lisl, who was originally from southern Germany, made some of the desserts for the restaurant like the chocolate mousse, the *crème brûlée* and the cheesecake, for which she was renowned.

In an article titled "The Civilizers" in the January 1986 edition of *Texas Monthly*, Patricia Sharpe wrote about Maxim's Greenway Plaza location:

> *Maxim's is the bastion of Houston's old guard, the secure haven of the River Oaks plutocracy. Wildcatter Glenn McCarthy, now 77, eats there three or four times a week (Glenn McCarthy built the Shamrock Hilton). Attorney for the defense, Percy Foreman, has his own table with ever present telephone....Bermann courted the moguls of oil, banking and ranching, and Maxim's at lunch quickly became the place in Houston to do business.*

As any successful restaurateur will tell you, other than serving the best food and providing a wonderful atmosphere, the job of the restaurateur is to please his customers, no matter what. Bermann did this to the extreme, understanding the whims and vagaries of his loyal patrons. This, of course, is how chicken-fried steak (CFS) made it onto the menu. The breaded beef tenderloin with gravy was called "Oilfield Trash" and was most popular at lunch, when the manly male clientele needed a dose of comfort food. Fancy French food might be fine for dinner with the ladies, but at lunch, CFS ruled the day. One of the famous chefs under whom Bermann studied was Henri Soulé of Le Pavillon in New York. Sharpe described how CFS made Bermann rich. When Henri Soulé took Bermann to task for serving chicken-fried steak, Bermann flashed his diamond-and-sapphire cufflinks at his old friend. "When I worked for you, Soulé," he huffed, "I had to use safety pins for cufflinks. Chicken-fried steak bought me these."

Ronnie and Mark Bermann. *Photo by Paul Galvani.*

We sat down with Mark and Ronnie Bermann, Camille's sons, to discuss how life was growing up in the restaurant. Mark tried out at the restaurant, but his father turned to him one day and said, "You'd better find something else to do," so he went to law school but found it boring. Mark noticed that there were plenty of liquor and beer distributors in Houston but none for wine, so he decided to open his own wine distributorship, the Pure Wine Company. "This was a time when the menus were huge but the wine list was tiny. Nowadays, the wine list is like a book. In 1969, it was very difficult to get any kind of wine listed at any restaurant in Houston," Mark said. "Camille called Houston a bourbon and branch water town. Those were the days of Mateus Rose, Lancer's and Liebfraumilch," added Mark. Ronnie took a different path. "I wasn't very good in school, so when I was thirteen, my parents took me out of school, and I started working as a busboy at the restaurant." When Ronnie turned sixteen, he was sent to France for two years to learn the business. His first year was spent in the French vineyards at Château Lascombes, the second as an apprentice chef at Fernand Point's La Pyramide and at the Hôtel de la Poste in Beaune. When Ronnie returned to Houston, he began working at Maxim's as a captain.

They both acknowledged that their father was a very shrewd businessman. In order to have a drink in Houston at that time, one had to be a member of a club. Being a club member at Maxim's showed that one was part of an elite group, and the lower one's membership number, the

longer one had been a member. Thus it became a badge of honor to have a low number, until one day, Camille's ruse was discovered. One member was very proud of being member no. 1 and showed his membership card to his friend—who shared the same membership number. "I think Dad issued about seventy-five membership cards each with the number 1," Mark admitted. "When the Offshore Technology Conference came to town, I remember my dad saying that there was a private party that took over the restaurant with the president of every major oil company in the restaurant at the same time and that if something were to happen to them, the stock market would crash," said Mark. Ronnie inherited his father's love of pranks, and one day, Tony Randall came in while he was still playing in the sitcom *The Odd Couple*. In the TV series, Randall played Felix Ungar, a neat freak. His opposite was Oscar Madison, a slob played by Jack Klugman. Both were separated from their wives and had to live together despite their immense differences. Ronnie prepared a dirty table next to Randall's and left it there most of the evening. Tony wore dark glasses and did not notice the table until his wife, who immediately got the joke, mentioned it to him, and he laughed. "I also did a good impression of Jerry Lewis when he came in, and he appreciated it," said Ronnie. After twenty years of serving fine French food, Camille was invited to Paris by the owners of Maxim de Paris. They bestowed an honor on him by officially approving the use of the Maxim's name on the Houston restaurant.

The National Association of Home Builders convention was held in Chicago, but in 1971, a three-year contract for the annual convention was awarded to Houston. Two weeks before the convention was to begin, officials from the organization visited Houston to ensure everything was ready. It was at that time that they discovered that you could not get liquor by the drink. A hasty meeting of the Texas Alcoholic Beverage Commission (TABC) was called in Austin, and the decision was made to offer private club status to any conventioneer—all they had to do was sign a membership card. The organizers advised the city that unless the law was changed, they would not be returning the subsequent years. In April 1971, Governor Preston Smith signed the Liquor by the Drink Bill into law, allowing restaurant operators to sell mixed drinks in addition to beer and wine.

Maxim's laid the groundwork for Houston to become the world-class restaurant venue it is today.

Maxim's Red Snapper Excelsior

4 red snapper filets
1 cup flour, seasoned with salt, pepper and a pinch of cayenne
4 tablespoons butter
2 tablespoons olive oil
1 cup chopped artichoke hearts
2 cups sliced mushrooms
Juice of 3 lemons
½ cup minced parsley
Salt and pepper, to taste
Pinch of chili powder
Lemon and parsley as garnish

Dredge snapper in seasoned flour until well coated. Heat 2 tablespoons butter and 2 tablespoons oil in a skillet over medium heat. Reduce heat to medium-low; add the floured filets, and fry each side for five minutes or until cooked through. Remove from the skillet and keep warm. Melt the additional 2 tablespoons butter in the skillet, and then add the artichokes and mushrooms, cooking for a minute or 2. Cover and cook for 4–5 minutes. Add the lemon juice and minced parsley to the skillet, stirring together and cooking for 2 minutes. Pour sauce over fish; season with salt, pepper and chili powder and garnish with lemon slices and parsley.

ONE'S A MEAL

(1920–79)

907 Rusk Street
1010 Texas Avenue
414 Main Street
Main & McKinney Streets
2923 Main Street
4422 Main Street
1202 Texas Avenue
2019 West Gray Street
2520 Amherst Street
324 Northline Mall
215 Gulfgate Mall
2252 West Holcombe Boulevard

2128 Portsmouth Street
Texas Avenue & San Jacinto Street
1021 Capitol Avenue
1125 Walker Avenue
5603 Almeda Road
9047 Sout Main Street
9307 Stella Link Road
5422 Bissonnet Street
Heights Boulevard
3939 Hillcroft Avenue

William Edward Gibson was born on December 19, 1876, in Grayville, Illinois. As an adult, he opened a piano business, the Gibson Piano Company, in Paducah, Kentucky, and married Kathleen Harper. They had one child, Kathleen Gibson. Following his

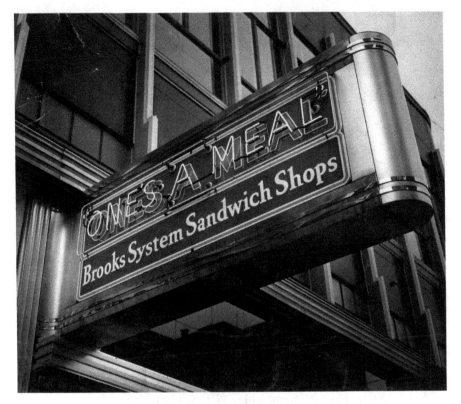

One's A Meal, 907 Rusk location, showing an early use of a neon sign. *Courtesy of Debbie Garrett.*

wife's death, William married Rollie James Kruger, who already had one daughter, Meredyth Kipping Scott. Together, they had two children, Don and Allen Gibson. The family moved to Dallas, where William Gibson met a Mr. Brooks, owner of a restaurant in Fort Worth. Brooks had developed the "Brooks System," an early form of franchising. In 1919, Gibson and his family moved to Houston. Soon thereafter, he traveled to Beaumont to learn the Brooks System from Brooks himself. The system was something new for the period: making food in full public view and focusing on the breakfast trade with a quick and easy meal. Gibson signed on with the Brooks System and licensed the name "Brooks System Sandwich Shops."

In 1920, Gibson opened his first Brooks System Sandwich Shop at 907 Rusk in downtown Houston. One's A Meal became the name of the restaurant about the time neon signs were becoming popular. The

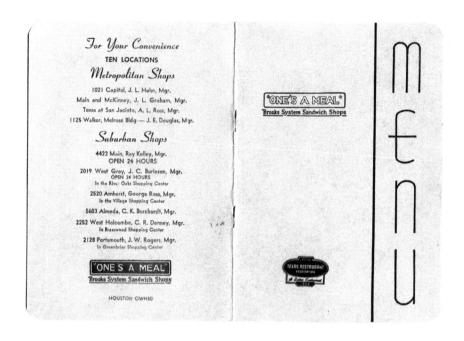

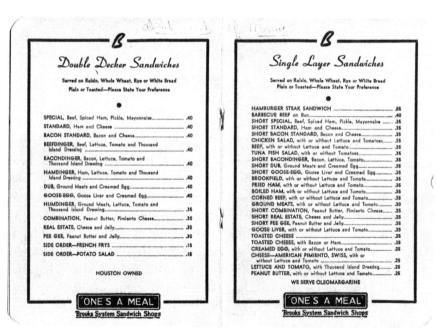

This page and opposite: One's A Meal menu, circa 1958. *Courtesy of Debbie Garrett.*

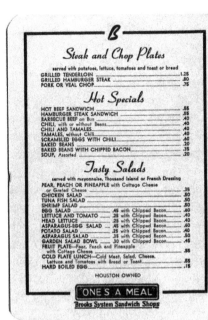

Steak and Chop Plates

served with potatoes, lettuce, tomatoes and toast or bread

GRILLED TENDERLOIN 1.25
GRILLED HAMBURGER STEAK80
PORK OR VEAL CHOP75

Hot Specials

HOT BEEF SANDWICH55
HAMBURGER STEAK SANDWICH55
BARBECUE BEEF on Bun40
CHILI, with or without Beans40
CHILI AND TAMALES40
TAMALES, without Chili40
SCRAMBLED EGGS WITH CHILI60
BAKED BEANS20
BAKED BEANS WITH CHIPPED BACON .. .35
SOUP, Assorted20

Tasty Salads

served with mayonnaise, Thousand Island or French Dressing

PEAR, PEACH OR PINEAPPLE with Cottage Cheese
or Grated Cheese35
CHICKEN SALAD50
TUNA FISH SALAD50
SHRIMP SALAD50
EGG SALAD45 with Chipped Bacon .. .60
LETTUCE AND TOMATO .25 with Chipped Bacon .. .40
HEAD LETTUCE25 with Chipped Bacon .. .40
ASPARAGUS-EGG SALAD .45 with Chipped Bacon .. .60
POTATO SALAD25 with Chipped Bacon .. .40
ASPARAGUS SALAD35 with Chipped Bacon .. .50
GARDEN SALAD BOWL .. .30 with Chipped Bacon .. .45
FRUIT PLATE—Pear, Peach and Pineapple
with Cottage Cheese55
COLD PLATE LUNCH—Cold Meat, Salad, Cheese,
Lettuce and Tomatoes with Bread or Toast .. .55
HARD BOILED EGG15

HOUSTON OWNED

ONE'S A MEAL
Brooks System Sandwich Shops

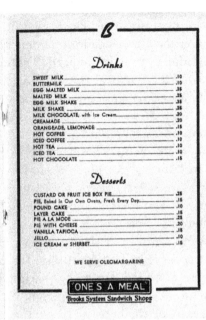

Drinks

SWEET MILK10
BUTTERMILK10
EGG MALTED MILK25
MALTED MILK25
EGG MILK SHAKE25
MILK SHAKE25
MILK CHOCOLATE, with Ice Cream .. .20
CREAMADE20
ORANGEADE, LEMONADE15
HOT COFFEE10
ICED COFFEE10
HOT TEA10
ICED TEA10
HOT CHOCOLATE15

Desserts

CUSTARD OR FRUIT ICE BOX PIE25
PIE, Baked in Our Own Ovens, Fresh Every Day .. .15
POUND CAKE10
LAYER CAKE15
PIE A LA MODE25
PIE WITH CHEESE20
VANILLA TAPIOCA15
JELLO10
ICE CREAM or SHERBET15

WE SERVE OLEOMARGARINE

ONE'S A MEAL
Brooks System Sandwich Shops

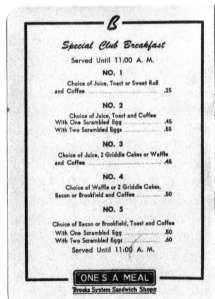

Special Club Breakfast

Served Until 11:00 A. M.

NO. 1

Choice of Juice, Toast or Sweet Roll
and Coffee25

NO. 2

Choice of Juice, Toast and Coffee
With One Scrambled Egg45
With Two Scrambled Eggs55

NO. 3

Choice of Juice, 2 Griddle Cakes or Waffle
and Coffee45

NO. 4

Choice of Waffle or 2 Griddle Cakes,
Bacon or Brookfield and Coffee50

NO. 5

Choice of Bacon or Brookfield, Toast and Coffee
With One Scrambled Egg50
With Two Scrambled Eggs60

Served Until 11:00 A. M.

ONE'S A MEAL
Brooks System Sandwich Shops

Breakfast Served . . All Day

HALF GRAPEFRUIT15
ORANGE JUICE15
TOMATO JUICE15
GRAPEFRUIT JUICE15
PINEAPPLE JUICE15
APPLESAUCE15
STEWED PRUNES15
MELBA HALF PEACHES25
COTTAGE CHEESE, with Cream or Milk .. .30
CEREAL, with Fresh Fruits and Cream or Milk .. .35
OATMEAL OR DRY CEREALS, with Cream or Milk .. .25
FRESH FRUITS, in Season with Cream or Milk .. .30
TOAST—Your Choice of Whole Wheat, Raisin, Rye
or White Bread10
MILK TOAST20
EGGS—Our Specialty—2 Eggs Scrambled, with Toast .. .45
WAFFLE, Plain with Choice of Maple or Cane Syrup .. .30
WAFFLE, Raisin35
WAFFLE, Pecan40
TWO GRIDDLE CAKES, Served until 11 A. M. .. .30
THREE GRIDDLE CAKES, Served until 11 A. M. .. .40
STRIP ORDER OF BACON—Two Slices .. .20
STRIP ORDER OF SAUSAGE20
STRIP ORDER OF FRIED HAM20
SWEET ROLL10
DO NUT05

WE SERVE OLEOMARGARINE

ONE'S A MEAL
Brooks System Sandwich Shops

use of neon was a novelty at that time. Gibson decided to put up a neon sign at the Rusk location, naming the restaurant for the double-decker sandwich that he introduced. The sandwich was so large that one could be considered a meal. Throughout the time the Gibson family owned the restaurants, they always used One's A Meal together with Brooks System Sandwich Shops. In addition to the use of neon signs, the One's A Meal restaurants also pioneered other innovations in the restaurant industry. They were the first to offer 24/7 service and round-the-clock breakfast. Soon, One's A Meal restaurants became the place to go for late-night snacks and meals, particularly after a night of clubbing. For many years, One's A Meal restaurants were the only after-hours restaurants in town. When the chain first started, Gibson served eggs for breakfast only one way—scrambled. This was to ensure they were quick and easy to make and consistent. He was strongly advised not to pursue this idiosyncrasy, but he prevailed. For many years, if you wanted eggs at a One's A Meal restaurant, they were scrambled. Naturally, scrambled eggs became the specialty of the house. "My mother used to make scrambled eggs at the house in the same way they made them at the restaurants, by adding some milk to them," Debbie Garrett, Allen Gibson's daughter, told us during an interview.

Gibson also insisted on a no-tipping policy. He believed in having well-trained and well-paid employees who were not serving customers just for the tip. Another innovation introduced by the chain was the use of a central commissary to make the food. All the pies and chili were made there. The rest was made fresh in the restaurant, right in front of the customers, with only bread, milk and ice cream delivered directly to the stores. This way, tight quality controls could be implemented, meaning that the same food was served no matter the location of the store.

In 1930, Gibson opened a second location downtown. The first stores had only counter service. However, as they expanded into newly developed shopping centers in suburban locations, they added booths and tables. In 1938, William's sons, Don and Allen, opened the West Gray location, near the newly developing River Oaks neighborhood. By the 1940s, they had six locations, three called "Metropolitan Locations" and three called "Suburban Shops." It is interesting to note that, at the time, the location on 2923 Main was considered the suburbs. Today, this location, two blocks north of Elgin, is in Midtown. In 1940, William Gibson, the company founder, became the president of the State Restaurant Association of Texas. He was also a director of the National

Restaurant Association and the Federal Food Administrator for the U.S. Army and Navy. He met an untimely death in a car accident in April 1941 in Oklahoma on his way to a meeting in Chicago concerning the design of army mess halls used during World War II.

During World War II, Don and Allen Gibson were both in the army; Don fought in Germany, and Allen served at the Aberdeen Proving Ground in Maryland. During the time the brothers were in the army, from 1941 to 1945, Roy Etchison became president of One's A Meal, and Rollie was vice-president. When the brothers returned, ownership and officers of the company changed. Rollie became president, Allen became vice-president and A.K. Scott (Meredyth's husband) became secretary-treasurer. Rollie remained president even after she died, an agreement that was made by the siblings to honor her. Etchison left to open Etchison's Quick Foods.

On June 5, 1953, sparks ignited a display of fireworks under construction at the Alco Fireworks and Specialty Company warehouse off Rosine Street, between West Dallas and West Clay. The fire set off forty-five thousand pounds of explosives. The fire chief at the time said it was the worst disaster to hit Houston in the thirty-eight years he had been with the fire department. The explosion could be felt miles away. The 1100 block of Waugh Drive was almost completely demolished. Five people were killed, and one hundred more were hospitalized. At the time, it was already illegal to set off fireworks in the city but not to assemble or construct them. The city quickly passed an ordinance making it illegal to manufacture, possess, store, transport and set off fireworks inside the city limits. The Brooks System Sandwich Shop commissary on 1116 Rosine Street, less than a block away, was completely demolished. The location had just opened three weeks earlier. Debbie Garrett filled in some other details for us:

Fortunately, the commissary staff had finished their work for the day and left the building some twenty minutes before the explosion and escaped the collapse of the kitchen ceiling. My uncle Don Gibson's office had a large plate-glass window in it overlooking the kitchen. However, my uncle Scotty was in Uncle Don's office, and when the window shattered, his face and his jugular were severely cut. The ambulance driver saved his life by taking him to the nearest hospital rather than to the county emergency room. Fortunately, the old commissary was still unrented, so they moved the operation back there while the new commissary was rebuilt. The restaurant community moved into action

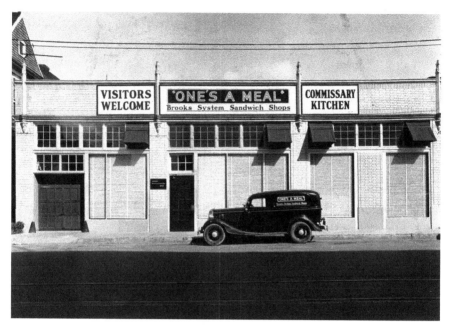

Photo of the One's A Meal commissary on 906 Louisiana. *Courtesy of Debbie Garrett.*

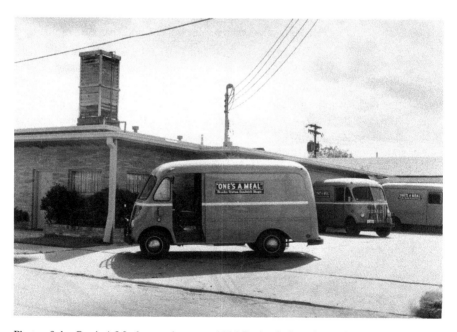

Photo of the One's A Meal commissary on 1116 Rosine before the explosion and fire that destroyed it. *Courtesy of Debbie Garrett.*

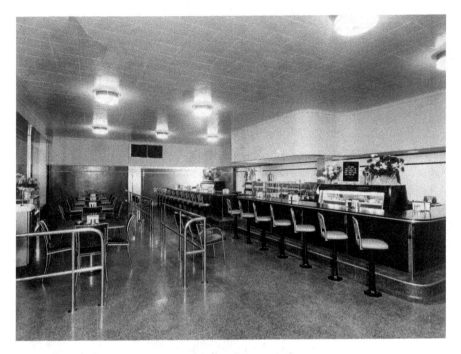

One's A Meal, River Oaks. *Courtesy of Debbie Garrett.*

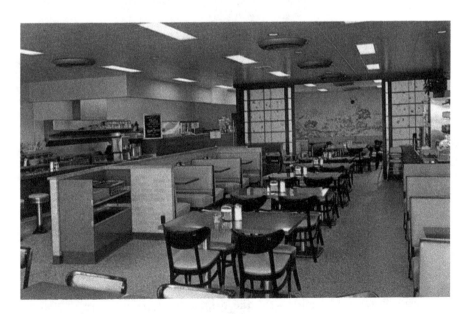

One's A Meal, 9047 South Main. *Courtesy of Debbie Garrett.*

to provide everything the business needed, and all of One's A Meal locations received things normally produced at the commissary. We were very thankful for that love and support, even though many customers said, "We're anxious to have One's A Meal homemade pies again."

By 1958, the chain had grown to eleven locations around the city with 250 employees and served 15,000 every day. At the peak of operations the Gibson family opened twenty-three locations, fourteen of them open at the same time. After 1960, the owners were Allen Gibson, Don Gibson and Meredyth Scott.

One of the hallmarks of success in the restaurant business is having tight quality and cost controls. Debbie Garrett related to us a story that shows the types of controls her father, Allen Gibson, instilled in his restaurants:

One's A Meal made their own pies at the commissary and sent them out, uncut, to each location. Managers were required to cut six generous slices and no more. Gibson thought that one of the managers was cutting eight slices to up his profits. The manager swore he wasn't, so Gibson told the commissary to put all of the pies going to that location in brand new pie tins and caught the manager red-handed with the proof in the cuts on the new pans.

Allen Gibson inherited another trait from his father. Both used to like to wait tables in the stores so that they could mingle with the customers and get a feel for what was going on day to day at the various locations.

By 1978, only the location at 2019 West Gray remained when Don and Allen moved it to 609 West Gray and sold it to brothers Harithos and Gregory Bibas, who merely added their family name. Thus, it became known as Bibas' One's A Meal. Harithos first landed in the United States in Boston when he emigrated from Greece in 1959. He, like many Greek immigrants before him, opened a restaurant. His was called Omonia. He followed this with restaurants in the New York and New Jersey area. In the 1970s, he visited Houston to evaluate the residential real estate market here and ended up buying the One's A Meal. The brothers had originally intended to turn the restaurant into a New York City–style deli, but the realty company that held the lease on the property persuaded them not to change something that had remained unchanged since the '20s. They decided to take things slowly. They kept the menu essentially the same, simply adding lemon to the chicken soup and feta to the salads at first, then adding more Greek dishes as time went on.

By 2000, they had shuttered the West Gray location and opened one on Memorial; Harithos kept the property on West Gray. Then, in 2010, Harithos rebuilt the West Gray location and opened his Bibas' Diner. In October 2011, he sold his Bibas' Diner to Joe Isaacs, and it was to be renamed Bibas Kitbar, with Harithos promising to drop by every once in a while. It, too, closed in 2012.

THE ORIGINAL KELLEY'S STEAKHOUSE

3512 South Main Street (1926–70s)
Kelley's Champion Corral 910 Texas Avenue
Kelley's Grill 302 Main Street
Kelley's Steakhouse U.S. 290, Hempstead Texas
Kelley's West 6015 Westheimer Road (1971–?)

Considering that George P. Kelley owned so many important restaurants for such a long time and was known as "Houston's Host to the Nation" and "the Dean of Houston Restaurateurs," remarkably little is known about the man. All that we know is that he owned five restaurants, all steakhouses, the Original Kelley's opening in 1926 at 910 Texas Avenue. Over the years, he owned another two restaurants on Main Street and one in Hempstead, then opened his last one in 1971 on Westheimer near Fountain View. All of his restaurants had a western theme, with interiors made almost entirely of wood. As with many restaurants of the period, oysters, in many different forms, appeared on the menu. Kelley had a remarkable way of promoting them. Here is what he printed on his menu:

Just day before yesterday at the crack of dawn these beautiful oysters were frolicking with felicity in the clean crystal cool water on the bottom of Grand Island Bay.

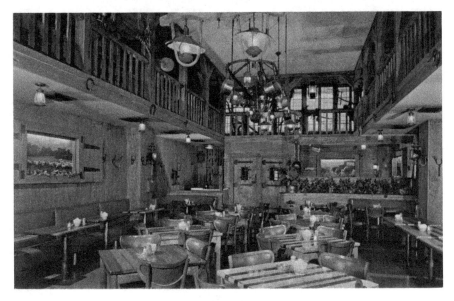

The back reads, "Kelley's Famous Corral Room is part of the famous Kelley tradition in Houston. A handsome Dining Room supplying Houstonians and visitors with REALLY FINE FOOD at really moderate prices. Oysters on the Half Shell served all year." *Authors' collection.*

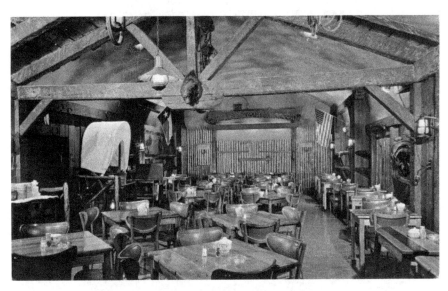

Kelley's Famous Corral Room is Houston's typically Texas welcome to travelers from everywhere—and Houston's own favorite downtown dining room. Here, really fine food, in the best Texas tradition, combines with really moderate tariffs, to produce family dining at its best. Oysters on the half shell are served all year. *Authors' collection.*

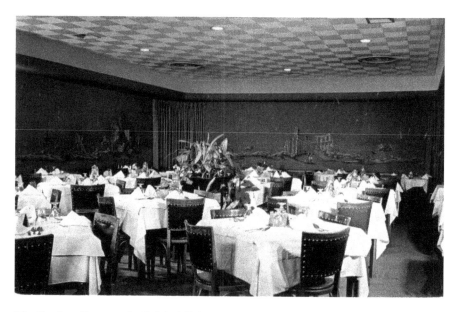

The Corsican Room at the Original Kelley's, 3512 South Main, is handsome and new in a rich dignified manner. Naturally, it features the same splendid food that has made Kelley's Houston's Host to the Nation. *Authors' collection.*

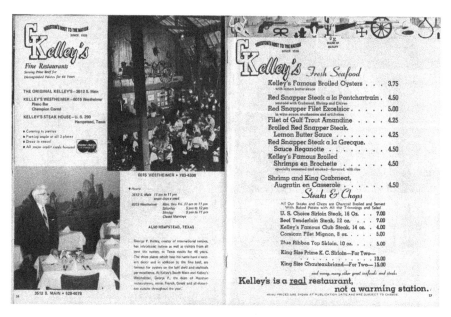

Dining Out in Houston, vol. 7, 1972. *Hospitality Industry Archives, Hilton College, University of Houston.*

Like the ancient vestals they were preparing for the supreme sacrifice, to give their lives to bring joy to mankind. One by one they were plucked from the water, inspected and shipped by fast freight to Kelley's for your enjoyment.

High in vitamins of the sea, they are juicy, plump, succulent and always fresh and flavory [sic].

Kelley was a relentless self-promoter. He claimed that his Original Kelley's Steakhouse on South Main was "the largest restaurant in the largest city in the largest state." This building was constructed in the Spanish Colonial style and was later sold to Christie's. It was torn down in 2007.

A menu from the 1940s lists "Campbell's Soups" and notes, "Military authorities have requested our cooperation. They ask that we do not serve men in the uniforms of our armed forces after the following hours: 11:30 P.M. Weekdays and Sundays 2:00 A.M. Sunday morning (Saturday Night)."

A side story related to Kelley's concerns a gentleman named Ben C. Heinemann, aka "Captain Benny." He came to Houston at age nineteen and got a job shucking oysters at Kelley's Restaurant. He worked there for nine years before going to work at Bill Williams Fried Chicken Restaurant on South Main, where he spent another fourteen years. One day, A. Nesbitt, the owner of the Stables Steak House nearby, walked into Bill Williams's restaurant and made him an offer. Nesbitt had built a restaurant in the shape of a boat and decided to sell it. Although Williams wasn't interested, Heinemann was. Captain Benny's Half Shell opened in September 1969 on Main Street. After four years in operation, the boat was moved closer to Greenbriar Avenue, where it remained for fifteen years. In March 1989, a new and streamlined version of the restaurant docked at 8506 South Main Street.

THE PIG STAND

(1922–2006)
2412 Washington Avenue

The Pig Stand chain of restaurants was a pioneer in developing new food offerings as well as in many areas of restaurant operations. It claimed to have invented the onion ring, Texas Toast and the chicken-fried steak sandwich. But perhaps the biggest mark The Pig Stand left on the culinary scene was the one item for which it became famous, the "Pig Sandwich," a Tennessee-style barbecued pork sandwich.

In 1920, not that many years after Ford's Model T was introduced (1908), Jesse G. Kirby made an astute observation about this new phenomenon. He noted that people were crazy about their cars and did not want to get out of them, even to eat. In 1921, he partnered with Ruben W. Jackson, a physician by training, opening a dining stand with no dining room. He called it Kirby's Pig Stand. This was the beginning of curbside service and in-car dining. The stand was located beyond the outskirts of town at the southwest corner of Fort Worth Pike Road and Chalk Hill Road in Dallas, catering exclusively to people in automobiles. He advertised this new concept as "America's Motor Lunch." He hired smartly dressed teenage boys, known as carhops, to serve people in their cars. The term *carhop* was coined for the antics of the servers. In the 1920s, cars had running boards, and since the carhops worked for tips only, they had to hustle to make any money, so as cars were approaching the stand, they learned to hop onto

the running boards of the cars, before they came to a stop, subsequently taking the orders from the car's occupants. The Pig Stand pioneered this type of curbside service. The young men, all of whom wore white shirts and bow ties, were later replaced by young girls, who became known as "car-hostesses." Later still, some chains put the girls on roller skates as an added attraction. The drive-in had arrived. Kirby died in 1926.

Kirby and Jackson quickly built restaurants all over Dallas, then expanded to Houston in 1922, with their first location, Pig Stand #7, on Washington Avenue at Sawyer Street. In addition to the Pig Stand #7, Houston also had Pig Stands on 4803 Main, the 6000 block of Harrisburg Boulevard and 1441 North Shepherd Drive.

They were among the first companies to develop the concept of a chain of restaurants. In 1925, they began to offer a new business model to hopeful entrepreneurs—the franchise. Jesse Kirby once famously said, "Give a little pig a chance and it will make a hog of itself." Pig Stands are also said to have been the first diners to use air-conditioning, neon signs and fluorescent lighting.

The chain peaked in 1930, with 130 locations in Texas, California, Louisiana, Mississippi, New York, Florida, Oklahoma, Arkansas and Alabama, many of them operating as franchises. By then, they offered full-service dining, but the automobile was still at the center of the company's DNA, because in 1931, they introduced a drive-through window, launching what was to become a mainstay of fast food restaurants, allowing customers to drive up, purchase food from the convenience of their cars and go about their business. In 1930, thirteen-year-old Royce Hailey of Oak Cliff asked the manager of the original Pig Stand for a job as a carhop. He persisted until the manager told him that he could have the job if he would go across the street and kiss a girl who was sitting in a porch swing. Hailey went across the street and explained his task to the girl. He got the kiss and the job. By 1955, Hailey had become president of the company, and twenty years after that, he became the sole owner. One day, Hailey had an inspiration at one of his Beaumont stores. He asked the local Rainbow Bakery to cut the bread a little thicker in order to make their sandwiches more substantial. When the first shipment arrived, it was too thick to fit into the toaster. The restaurant cook saved the day by suggesting they slather it with butter and cook it on the griddle. Thus Texas Toast was born. The Pig Stands also take credit for inventing a breaded and fried steak placed between two bun halves—the chicken-fried steak sandwich. In 1929, a Pig Stand cook accidentally dropped a slice of onion into some batter and then, on a whim, placed it into hot cooking oil. The rest is onion ring

history. During the '30s and '40s, they introduced twenty-four-hour service and new menu items like "Chicken in the Rough," tamales, enchiladas and "Hamburger Steak with Creole Sauce"

During World War II, rationing of food and gas had a substantial negative impact on the company, and after the war, it struggled to compete with newer drive-ins. By the end of the 1950s, all of the franchises outside of Texas had closed. By 1961, there were only twenty-three left, all of them in Texas. By 2005, when the company filed for bankruptcy protection, Texas Pig Stands Inc. was based in San Antonio and had only six Pig Stands remaining. Two were in San Antonio and the others in Houston, Beaumont, Lytle and Seguin. All were owned by Richard Hailey, the son of Royce Hailey, the former Pig Stand carhop who had risen to become owner of the chain.

The signature dish was a Tennessee-style barbecued pork sandwich: the "Pig Sandwich," which consisted of tender slices of barbecued pork with sour relish and a special sauce on a bun. It was available as a "junior" or "senior." The Pig Stand was also a popular place for breakfast, especially on weekends, serving hot cakes, rib-eye steak and eggs, pork chops and eggs, chicken-fried steak and eggs and a "Pig Out Breakfast," consisting of two eggs, bacon, sausage and ham, hash browns or grits and toast or biscuits. Fountain drinks included old-fashioned malts and milkshakes, topped with whipped cream and a cherry. They were also famous for their "Black Cow"—a frosted mug of root beer float with whipped cream on top. Desserts were always some sort of cake or pie. The interior had a throwback old-time look and atmosphere with vinyl-covered benches lining the walls. Old Coke bottles and pig figurines lined the windows and display cabinets inside.

Pig Stand #7 will be forever memorialized in the 1996 movie *The Evening Star*, based on the book by Larry McMurtry. This was a sequel to the 1983 movie *Terms of Endearment*. It starred Shirley MacLaine as Aurora Greenway. The movie takes place in Houston. Her therapist, played by Bill Paxton, invites her out, and she takes him to the Pig Stand #7 on Washington Avenue, where she knows everyone by name. In one scene, she downs three Pig Sandwiches followed by pie and ice cream.

SAN JACINTO INN

(1916–87)
4406 Battleground Road

Mention the beloved San Jacinto Inn to people who remember this restaurant and watch their eyes light up as they start talking nonstop about the all-you-can-eat seafood, the biscuits, the oysters, the shrimp, the fried chicken and so on, all of which was served family style until you could eat no more. Perhaps this restaurant's appeal had more to do with quantity than quality, but few restaurants elicit such excitement and nostalgia.

In 1916, Jack and Bertha Sanders opened a small seafood shack on the north side of the ferry landing in Lynchburg, on the Houston Ship Channel. It consisted of five tables. Jack fished, and Bertha cooked the catch of the day and served it with homemade biscuits and preserves, something for which she was to become famous. (See the biscuit recipe following this section.) In 1918, they moved to an old dance hall on the other side of the channel, near the San Jacinto Battleground. Fire destroyed this new location in 1926. In that same year, they constructed a two-story building that survived until 1977, when subsidence of the land under the building forced its demolition. A new building was constructed one hundred yards away and looked so much like the original building that most people did not know it had moved. Downstairs, there was a private dining room called the Cave. It was constructed to look like the inside of a cave and was used for private

Original sign for Santa Anna's Retreat from the San Jacinto Inn. *San Jacinto Inn Papers, MC 203, San Jacinto Museum of History; photo by Paul Galvani.*

parties and corporate events. There was also a cocktail lounge called Santa Anna's Retreat. A tradition that dated back to the 1930s was for people to sign the oversized leather-bound guest books; they eventually lined one wall of the restaurant for everyone to see and remember all the times they visited. During the 1930s and early '40s, a dance orchestra performed at the restaurant. Behind the Inn was a bunkhouse built expressly for employees needing overnight lodging.

The San Jacinto Monument was constructed between 1936 and 1939, and in 1948, the battleship *Texas* was permanently docked at the location next to the restaurant and across from the monument. The Inn helped in the building of the San Jacinto Monument. When the base of the monument required fifty-seven hours of continuous concrete pour, the San Jacinto Inn served sandwiches and coffee to the workers every four hours.

While the menu never varied, it did have a winter dinner and a summer dinner: crabs, both boiled and stuffed, during the summer and oysters in the winter being the only difference. The menu consisted of celery, olives, shrimp cocktail, oysters on the half shell, fried oysters, tenderloin of fish, fried chicken, French-fried potatoes, hot biscuits with homemade strawberry or black cherry preserves and sherbet. When the Sanderses first opened, they charged $1.00 for this feast and raised it to $2.00 in the 1930s. When the Inn closed its doors in the late 1980s, the price had risen to $18.95. In 1925, when a national advertising conference being held in Houston hired the restaurant to serve attendees, some five thousand people were fed at picnic tables lined up on the bayou. Word spread fast about the San Jacinto Inn, and the restaurant's fame was secured.

Left: One of the many leather-bound guest books, this one from 1929, that were signed by the guests. *Gladys Poe Papers, MC201, San Jacinto Museum of History; photo by Paul Galvani.*

Below: Al Jolson's entry in the guest book from 1929. *Gladys Poe Papers, MC201, San Jacinto Museum of History; photo by Paul Galvani.*

One thing that many people noted about this place was the quality of the service. The Inn was blessed with a loyal staff, many of whom worked there for forty years or more. The waiters and busboys were all required to wear dress slacks and starched white jackets and black ties. The famous biscuits were handmade by a woman who was called Miss Pearl and then later "Granny." The tartar sauce and red sauce were also made from scratch. The shrimp and crab preparation was done in an area below the main restaurant floor. Two cooks prepared the crab and shrimp in a large steamer. Once the shrimp were cooked, they had to be

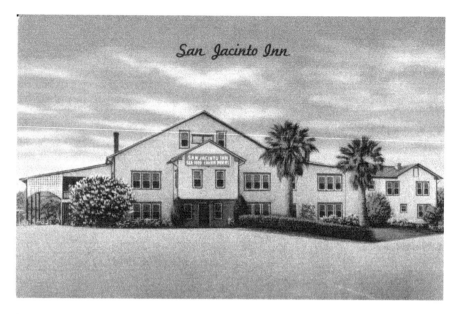

San Jacinto Inn. The back reads, "Located at the famed San Jacinto Monument and Battlegrounds, only 21 miles from the heart of Houston, Texas." *Authors' collection.*

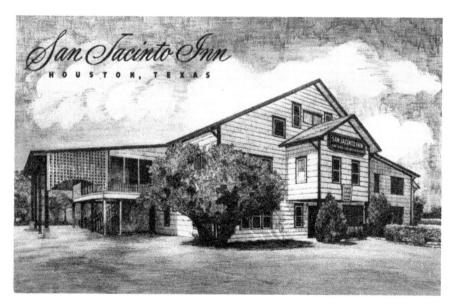

San Jacinto Inn, Houston, Texas. The back reads, "Nationally famous for its seafood and chicken dinners. Near San Jacinto Monument, only 30 minutes from downtown Houston." *Authors' collection.*

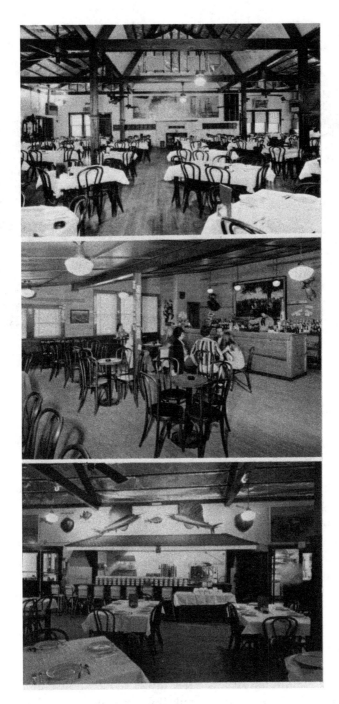

San Jacinto Inn & Santa Anna's Retreat Cocktail Lounge.
Authors' collection.

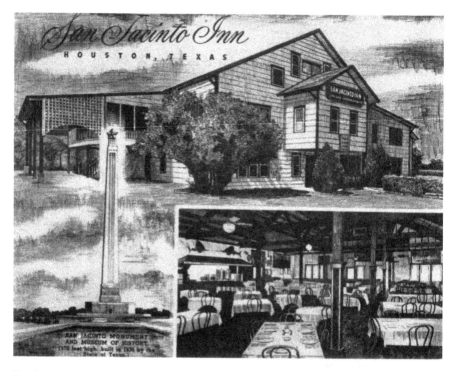

San Jacinto, Inn Houston, Texas. The back reads, "World Famous for its seafood dinners—open since 1917—located in the shadow of the San Jacinto monument, adjacent to the Battleship Texas. Over 8 million meals have been served in this traditional old style restaurant. The San Jacinto Inn is internationally famous for its seafood and chicken dinners, served family style all year round." *Authors' collection.*

cleaned. Busboys and any available employee all assisted in this task. One employee remembered that no guest was ever served a shrimp unless the vein was removed.

An advertisement from the 1950s informed us that the "San Jacinto Inn, in an average year, serves 85,000 pounds of fish, 55,000 chickens, 200,000 pounds of shrimp, 1,700,000 oysters, 50,000 crabs and 500,000 hot biscuits." The spacious, barnlike dining room accommodated seven hundred customers and was full most of the time.

In the 1930s, Jack and Bertha divorced. Jack went on to open the Pier 21 Restaurant in Houston, and Bertha continued to make her famous biscuits and run the San Jacinto Inn until she died in 1952. Bertha's niece, Gladys Poe, operated the Inn until 1967, when it was acquired by John T. Jones Jr. (father of Jesse H. Jones) and J. Frank Bobo, owners of the Battleground Corporation, who operated it in the same style as the original owners

San Jacinto Inn <u>BISCUITS</u>

4 cups flour Oven Temperature
3 teaspoonfuls baking powder 400 to 425
1 teaspoon salt
1 teaspoon sugar Time - Bake until
3/4 cup shortening brown
1-3/4 cup milk (10 to 12 minutes)

Method: Sift Flour and dry ingredients in mixing bowl,
 add shortening and milk and work with hands on
 lightly floured board. Roll out and cut with
 biscuit cutter.

Yield - 20 large biscuits

Recipe card for the San Jacinto Inn's biscuits, handed out to patrons on request. *San Jacinto Inn Papers, MC 203, San Jacinto Museum of History*.

until it closed its doors on February 15, 1987. In 1988, the Battleground Corporation sold the property to the Texas Parks and Wildlife Commission, which needed access and extra space for the restoration of the USS *Texas*. The Texas Parks and Wildlife Commission paid $900,000 for the property.

SHIP AHOY

1007–9 MAIN STREET (1935–47)
6638 MAIN STREET (1947–60s)

The Only Unique Sea Food Yacht Restaurant in Houston

The first location of the Ship Ahoy restaurant in Houston was at 1007 Main Street, which had previously been the Hollywood Grill from 1933 to 1934 and the Blackstone Grill from 1934 to 1935. After Ship Ahoy moved to 6638 Main, 1007 Main became the Normandie restaurant. When the location at 6638 Main closed in the 1960s, it became the Galley Restaurant, which, by the mid-1970s, turned into Cathay House. There were four other Ship Ahoy restaurants, in Atlanta and Augusta, Georgia, Charlotte, North Carolina, and Columbia, South Carolina, that were a part of this small chain. A restaurant called Ship-ahoy (different spelling) was in Corpus Christi but not affiliated with the chain.

This was one of many nautical-themed restaurants that were popular during this era. According to Jan Whitaker, who wrote an article titled "Ship-theme Restaurants" for *Restaurant-ing through History*, nautical-themed restaurants emanated from ocean-going liners and river steamboats that were some of the main forms of transportation in the nineteenth century and on which people were fed in lavish style. This was followed by the turning of a ship into a restaurant, which first occurred in 1852, when an Italian immigrant, Frank Bazzuro, opened his restaurant on one of the hundreds

of ships abandoned in San Francisco Bay. The next step was to take the nautical idea and build a ship on dry land. The first instance of this was a replica of a Spanish galleon built on Venice Beach, California, in 1904.

The interior of the 1007–9 Main location was decorated with ships' masts, brightly colored fabric sails and what appeared to be some sort of rigging. Postcards of the Atlanta and Columbia locations show an almost exact replica. The location on 6638 Main had more of a subdued maritime theme. Both the Atlanta and Columbia versions state that "the restaurant is one of the show places of (Atlanta, Columbia) and the South."

The daily special dinner menu from 1940 tells us some interesting things about the restaurant: "Ship atmosphere with Private Cabins. Unique Ship Service. Air Conditioning. Ship Ahoy restaurant is one of the showplaces of Houston and the Southwest." The menu has some interesting offerings. Calf sweetbreads *Financière*, calf liver, calf brains and eggs and chicken liver omelette and goose liver. These last three dishes on the main menu have long since disappeared or are not easy to find on menus today. Offal and other unusual animal parts were more readily accepted and available during this period, perhaps because it was only a few years removed from the end of the Great Depression, when people had difficulty putting any kind of food on the table. Frog legs also seem like a surprisingly adventurous offering for the time. Restaurants of the period tried to broaden their menus to appeal to as many diners as possible, so even though this was a seafood-themed restaurant, it offered lamb chops, veal, chicken and, of course, beef in many forms. We also learn that seedless grapes were available at this time. Finishing a meal with cheese, a very French thing to do, was also interesting, with "Roquefort, Camembert, Gruyer [sic] or Philadelphia Cream Cheese" being offered. The printed menu had a section titled "Italian Menu," again to broaden the appeal, with offerings such as "Genuine Italian Spaghetti and Roman [sic] Cheese," "Spaghetti Raviolas [sic]" and "Grecian Spaghetti with Mushrooms." The main menu also had an extensive list of offerings under the title "Chinese Menu," with typical American-style selections such as chow mein and chop suey, yet one that was surprising for its exoticism was called "Yet Ca Mein," described as boiled noodles.

SONNY LOOK'S

Quitman Coffee Shop, 604 Quitman Street (1946–48)
Sonny Look's, 715 Quitman Street (1947–59)
The Oaks, North Shepherd Drive at 610 Loop (1952–53)
Look's Sir-Loin House, 6112 Westheimer Road (1959–77)
Look's Sir-Loin Inn, 9810 South Main Street (1967–91)
The Depot 212 Milam Street (1971–78)
Don Quixote 6400 SW Freeway (1975–77)
Bar-B-Q Barn, 5109 Kirby Drive, 4005 Westheimer Road,
Longpoint Road near Blaylock Road, Broadway Street, 5625
Fondren Road (1960s)

Garret Dawson "Sonny" Look was born in 1919, in Caldwell, Texas. At the age of fourteen, he took an after-school job for a dollar a day at the New York Café, just off the main square in Brenham. The Greek owner, Gus Pitchios, became a father figure for Sonny. In 1940, at the age of twenty-one, Sonny borrowed some money and bought the restaurant from Gus. In 1942, he married Mary Reynolds and joined the navy as a ship's cook first class. He served on the USS *Beagle* in the Pacific Ocean. When Look left Brenham, he sold the restaurant to the owner of a local taxi cab company with a handshake, understanding that he was to buy it back when he returned from the war. Upon his

return, however, the owner did not honor the agreement. So, in 1945, Sonny moved to Houston and signed a two-year lease at a bar and grill on Riesner Street, where the police station now stands. It was a small place, seating eighteen people in total, twelve at tables and six at the bar. Sonny sold sandwiches, soups and other light fare. After forty-five days, the owner told Sonny that the food he was preparing was too good for the place and that he could do much better elsewhere, so he released him from the rest of the lease.

Sonny's next move was to the Quitman Coffee Shop, which he leased for two years. After that, he moved into the space down the road on Quitman that used to house the Lark Restaurant, changing the name to Sonny Look's. In 1952, Sonny purchased a restaurant called the Oaks on North Shepherd. He was forced to sell this a year later when Loop 610 was built and his property was in the right of way. In 1959, he opened Look's Sir-Loin House at 6112 Westheimer Road, where the Palm Restaurant now stands, in the newly built Briargrove Shopping Center, at that time considered to be on the outskirts of town. His wife, Mary, served as cashier and office manager. She died from cancer in 1964. In 1967, Sonny opened Look's Sir-Loin Inn, a thirty-seven-thousand-square-foot, 1,400-seat restaurant, just north of 610. The theme was that of a Tudor manor house. It was the largest free-standing restaurant in Texas and the third in the nation. This was followed in 1971 by the Depot, a railroad-themed restaurant on Milam Street at Market Square. The following year, Sonny had an eighty-eight-foot Santa Fe dining car delivered to the lot next to the Depot and remodeled for use as a cocktail lounge. It was hauled into place by a crane one Sunday, when the traffic downtown was light. In the 1960s, Sonny opened five Bar-B-Q Barns. The one on Kirby Drive turned into what is now Goode Company Bar-B-Q. His partners in the barbecue operations were Alfred Kahn of Alfred's Delicatessen, H.A. Hoddy Franz and John Goodman. They later sold the barbecue to Leonard McNeil, owner of Lenox Bar-B-Que. In the mid-1970s, Sonny purchased Don Quixote on the Southwest Freeway between Westpark Drive and Hillcroft Avenue, selling it two years later.

Sonny also ventured into the hotel business, starting in 1967, when Bruce Weaver Sr. asked him to invest in a new Ramada hotel being built on South Main. Together with Weaver, Sonny built or bought a total of ten hotels, mostly in the Houston area but extending ultimately to Beaumont, College Station and Wichita Falls. The company was called Texas Interstate Ramadas. Later it became Sunbelt Hotels Inc.

Sonny was an entertainer and showman at heart, from the flamboyant, brightly colored brocade jackets that he wore every night, made by his tailor and friend Frank Ortiz of Galveston, to the full-size knight in armor with a lance that he had sitting on a white horse in front of his restaurant, greeting customers as they entered. Every night, Sonny would wear a different colored jacket. At one point, he had four restaurants and kept jackets at all of them. When he would go from restaurant to restaurant, he would change jackets. He would tell people, "If you see me in this coat twice in one night, the coat's yours." "Over the years, Frank made me hundreds of jackets from the fanciest and most elaborate fabrics he could find," Sonny once told an interviewer.

Sonny first saw the knight on a white horse at the Green Gables Restaurant in Arizona and loved the idea. He kept four white horses stabled on Greenridge Drive, a block or so from the Sir-Loin House. One walked to the Sir-Loin House; the other was taken by trailer to the Sir-Loin Inn each day. The horses did two weeks at the restaurants and then rested for two weeks while the other two did "guard duty."

Sonny was instrumental in establishing the Conrad Hilton College of Hotel and Restaurant Management at the University of Houston. He was also one of the founders of the Greater Houston Convention and Visitors Council, serving as its chairman from 1980 to 1982. Sonny's civic activities included being a lifetime vice-president of the Houston Livestock Show & Rodeo, often buying the show's champion steers. Sonny was also on the board of the National Restaurant Association and was president of the Houston and Texas Restaurant Associations.

On March 31, 1967, Carole Peterson, her sister and mother were celebrating the mother's birthday. They had tried to make reservations at a number of restaurants around town, but everything was booked solid. Then someone suggested going to the Sir-Loin House. While they were waiting to be seated, Sonny came over and introduced himself to the trio and signed a photograph of himself and the knight on horseback, which he gave to Carole's sister Jan. When he discovered that Carole was new to Houston, he invited them all to the private club for an after-dinner drink. This led to Sony inviting Carole to go horseback riding, something they shared in common. It took her three months to agree to go out with him. The relationship blossomed, and in 1968, they were married.

Sonny was one of the restaurateurs responsible for educating Houstonians about wine, something they were just beginning to experience. He started pouring glasses of rosé for people in the waiting area. At the time, Texas

law prohibited liquor by the glass, except in private clubs. At Sonny's place, you could join the club for one dollar. You could, however, give away as much as you wanted. Sonny was instrumental in getting the law changed. Sonny's second wife, Carole, told me this was one of the many things Sonny was very proud of. "He asked the politicians which they thought was better: customers buying a drink at his restaurants or bringing in their own bottle and finishing all of it?"

With all of his restaurants and hotels, Sonny was always busy; however, Carol recalls that "he was not what you would call a work-a-holic. He always had time for me and the family".

The decor of Look's Sir-Loin House was that of an English Tudor manor. The interior had low ceilings with exposed wood beams, red carpet, red wall coverings and wood paneling and red tablecloths throughout. Elaborate, candelabra-style chandeliers provided the light and added to the regal atmosphere. An interesting aside regarding these chandeliers is that they ended up in the Mockingbird Bistro, before it, too, closed in December 2016. The main dining room could be set up banquet style with a throne at one end; otherwise, tables with comfortable chairs were set not too close to each other. Coffee and after-dinner drinks were served in gold cups. When Sonny started this tradition in the '60s, they cost him five dollars each. By the time he stopped using them in the '80s, they cost him sixteen dollars each, which might still have been acceptable to Sonny, except that they were a very popular item to take from the restaurant as a souvenir.

In 1968, the menu from Sir-Loin's consisted almost entirely of meat, as was common at the time. Prime sirloin, rib-eye, tenderloin, prime rib and a twenty-four-ounce Chateaubriand with Bordelaise sauce for two were the primary offerings. They were known as "Our Royal Family." Appetizers included a King Henry VIII Tidbit plate consisting of three Bar-B-Q shrimp, three Danish lobster tails and three stuffed shrimp ($4.95). Surprisingly, there was French onion soup with Parmesan croutons as well as vichyssoise with zest of chives, hot or chilled ($0.75). The back of the menu indicated the sole method of cooking meat employed at the restaurant: "Broiled steaks, which means cooking over an open fire was the first culinary method ever employed. It has never been improved upon."

Sonny pioneered many an innovation at his restaurants. He was famous for having four different flavored butters on the table. There was honey, orange, garlic and plain butter available. There was also a relish bucket on every table filled with raw carrots, celery, turnips, pickles and olives. During special occasions, such as Mother's Day, Thanksgiving, Valentine's

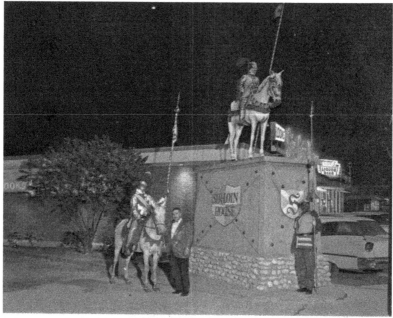

Look's Sir-Loin House. The back reads, "Back in the olden days, legend has it, King Henry VIII of England was served that choicest of beef from the loin of a grain-fed steer. It is no wonder the King Knighted the Steak that is to this day called 'Sir-Loin'. We like to believe that the King finished his steak—it was a Knight Well Spent!" *Authors' collection.*

Sonny Look's Depot interior. The back reads, "Reminiscent of the Golden Era of the railroads." *Authors' collection.*

Day, Easter and other holidays, Sonny hired a photographer to take complimentary pictures of guests and subsequently mailed them, as a courtesy, to the customers.

On November 13, 1991, Sonny suffered a stroke. On December 31 of that year, Sonny Look's Sir-Loin Inn closed. After his stroke, his wife, Carole, sat down with Sonny to record his history, thoughts and philosophy. When asked about the secret to his success, Sonny said, "The Look restaurants were successful due to hard work and long hours. I was there on the properties to oversee everything that was done. I promoted the business and entertained the guests as if I were at home." When asked if he had any advice for students and alumni of the Conrad N. Hilton College of Restaurant Management, he replied:

> *My motto has always been, the harder you work, the luckier you get. I would advise students and alumni to work hard, perform like champions, have pride in your work, never be a quitter, put forth that little extra effort, and give back to the community. Be honest in all things. An untruth, a shady deal, or an unsavory business practice will catch up with you. There is no substitute for integrity.*

Wise words, indeed. Sonny died on December 29, 2003, at the age of eighty-four. He is buried in Memorial Oaks Cemetery.

Look's Sir-Loin Dressing and Dip

1 egg
4 ounces vegetable oil
½ teaspoon dry mustard
¼ teaspoon Tabasco® sauce
Juice of two lemons
1 teaspoon Worcestershire® sauce
Salt and pepper to taste
2 avocados, peeled and de-stoned
3 shallots, finely chopped
1 clove garlic, finely chopped
4 anchovy filets
4 ounces mayonnaise
½ teaspoon saffron (optional)

Blend egg, oil and mustard. Add Tabasco, lemon juice, Worcestershire and salt and pepper to taste. Grind the avocados, shallots, garlic and anchovies into a smooth paste. Add mayonnaise and saffron, if using, and mix everything together. Chill before serving. This can be used as a dip or a salad dressing.

TRADER VIC'S

(1965–87)

THE PAVILION AT THE SHAMROCK HILTON
THE EMERALD ROOM AT THE SHAMROCK HILTON

On 1949, oilman and king of the wildcatters Glenn McCarthy opened the Shamrock Hotel, and what better day to open it than on St. Patrick's Day? The hotel sat on fifteen acres of land at the corner of Main Street and Holcombe Boulevard. Close to fifty thousand people attended the grand opening, which was reputed to have been the wildest party Houston had ever seen. Frank Sinatra was one of the headliners for the grand opening event. It was during this event that the secret romance between Sinatra and Ava Gardner was revealed to the world. Kitty Kelley, in her book *His Way: The Unauthorized Biography of Frank Sinatra*, told the story of how it all transpired. Frank and Ava went to dinner as guests of Mayor Oscar Holcombe at Vincent's Sorrento, which was owned by Tony Vallone, whose son, also called Tony, owns some of the best restaurants in town. A photographer for the *Houston Post* by the name of Edward Schisser spotted them and was about to take a picture when Sinatra jumped up and tried to grab the camera. Ava buried her head in her mink coat, Tony Vallone rushed over to escort the photographer out of the restaurant and calm was restored. The story, however, was published in the following day's paper and picked up on the wire services, making public a secret romance that had started eighteen months before.

The Pavilion Room at the Shamrock Hilton. The back reads, "The Pavilion at the Shamrock Hilton. The South's finest dining room, where everything is in keeping with the décor and the menu is so reasonably priced." *Authors' collection.*

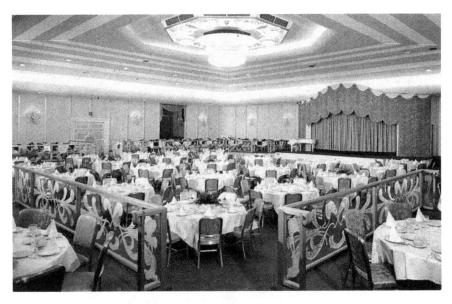

The Emerald Room at the Shamrock Hilton. The back reads, "One of the nation's outstanding grand ballrooms, the Emerald Room will seat 1250 for a banquet, 1600 for meetings. 103 x 103, without obstructing columns, this room is the scene of most of the city's leading functions." *Authors' collection.*

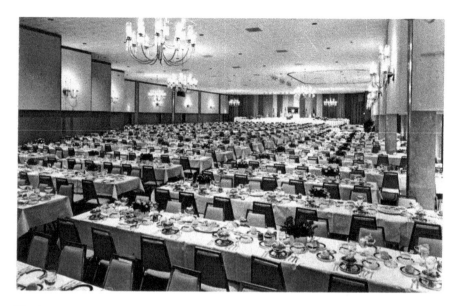

The Regency Room at the Shamrock Hilton. The back reads, "The Regency Room seating more than 1800 people for banquets. This beautiful room seats 2500 people for meetings or converts into exhibit area, being directly connected to the Hall of Exhibits, making a total of 42,000 square feet of exhibit area." *Authors' collection.*

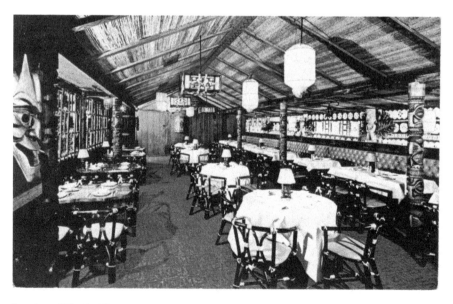

Interior of Trader Vic's at the Shamrock Hilton. The back reads, "Famed the world over for excellent foods and exotic beverages in a relaxing tropical atmosphere." *Authors' collection.*

The hotel housed a number of ballrooms, including the Emerald Room, a large ballroom with everything decorated in emerald green, a tribute to McCarthy's Irish ancestry. Then there was the Cork Club, a nightclub that featured big-name entertainment. The hotel had eighteen floors, 1,100 guest rooms and a fifty-meter Olympic-sized pool with three- and ten-meter diving platforms. As with many things Texan, it was the largest hotel swimming pool in the world at the time. The pool was large enough to accommodate a boat and water skiers. Scattered around the pool were cabanas for people to lounge and relax. The pool area was dubbed the Houston Riviera, as the city's social elites congregated there. It was a crown jewel of Houston and soon became *the* symbol for the city. The property was acquired by Conrad Hilton in the mid-1950s and renamed the Shamrock Hilton. Trader Vic's opened in the Shamrock Hilton in 1965 at the height of the fascination of all things Polynesian. It got its start, however, much earlier, in Oakland, California

In 1934, Victor Jules Bergeron Jr. borrowed $500 and opened a small food and beer joint opposite his parents' grocery store on San Pablo Avenue and Fifty-Sixth Street. It was called Hinky-Dink's. After Bergeron visited the tiki-themed restaurant Don the Beachcomber, in Los Angeles, a tropical flair began to pervade the décor and menu of Hinky-Dink's. Soon thereafter, he changed the name to Trader Vic's after his nickname, given to him by his first wife, Esther, because he would barter booze and food for supplies and services. In 1940, the first franchised Trader Vic's opened in Seattle and in 1950, Bergeron opened one in Hawaii. There soon developed a cult and fad for all things Polynesian, and at the height of its success in the 1950s and 1960s, there was a total of twenty-five Trader Vic's open at one time. Altogether, the company opened and closed thirty-five Trader Vic's locations. Today, there are nineteen locations worldwide, with only two left in the United States, in Emeryville, California, which is home to the company headquarters, and Atlanta, Georgia. It was one of the first themed chains of restaurants.

The term *tiki* is a Maori word describing a physical representation of an ancestral figure usually carved in wood or stone. Trader Vic's was decorated with tiki carvings, wooden masks and other artifacts from around the globe. Tiki gods guarded the entryway, which had a pointed roof. The inside was dark, tropical paradise with wicker furniture. It was like stepping into another world. It is difficult for us today to appreciate just how popular tiki bars were in the 1950s and '60s. Every city had more than one tiki bar. There developed a sort of cult of Polynesian culture,

and the elaborately decorated bars and restaurants were mirrored in other places, such as bowling alleys, miniature golf courses and homes and backyards, and then translated to other forms of popular culture like dress, music, TV shows and movies. Tiki-themed parties were all the rage during that time. It was like the whole country had developed a fascination with the South Pacific.

Bergeron claims to have invented the mai tai drink in 1944; *mai tai* is Tahitian for "very best." The exotic rum-based drink mixed with Curaçao and lime juice took America by storm, especially after 1945, when U.S. troops returned home from the Pacific arena full of tales of women in grass skirts, drum festivals and tropical fruits. This was the official start of the love affair with all things tiki. He also invented a number of other rum-based tropical cocktails with names such as Missionary's Revenge, Sufferin' Bastard, the Samoan Fog Cutter, the Tiki Puka Puka and Scorpion Bowl. Some were even set alight for effect, while others were served in hollowed-out pineapples or ceramic tiki mugs that you could take home with you. Trader Vic's was all about the sensual experience of the place, but the drinks were much more important than the food, which Bergeron admitted was certainly not authentic. It was American Chinese food jazzed up with some pineapple and coconut. It was somewhat familiar yet exotic enough. The whole idea was to encourage people to lose their cares and fantasize about being in a far-off exotic land, a paradise even, then get completely wasted. The menu let customers know that the Trader Vic's was "Dedicated to those merry souls who make drinking a pleasure" and alluded to the potency of the drinks: "Persuasive ammunition for toppling giants" and "No sissy drink, this!" Above all, Bergeron was a self-promoter like no other. He made up stories about how he was born on a tiny South Pacific Island and that he lost his leg to a shark. He even allowed patrons to stick toothpicks in his wooden leg. He was born in San Francisco in 1902 and did lose his leg when he was six, but it was to tuberculosis of the knee.

While Trader Vic's became synonymous with everything tiki, it was New Orleans native Ernest Gantt, of Don the Beachcomber fame, who opened the first tiki bar in Los Angeles, in 1932. Bergeron freely admitted that he stole the idea from Gantt. Gantt eventually changed his name to Donn Beach to add a touch of authenticity to his restaurant.

In 1951, *Life* magazine declared Bergeron the "Aristotle of Alcohols" and dubbed him the "undisputed monarch of South Seas fixings." For many Americans, Trader Vic's was the most exotic place they had ever seen.

LOST RESTAURANTS OF HOUSTON

Victor Bergeron died in October 1984. The chain hit hard times during the 1980s and 1990s, as younger people could not relate as much to the chain's tiki theme.

Alas, the Shamrock Hilton hotel, too, fell on hard times in the 1980s, losing out to more modern hotels. It was demolished in 1987 and turned into a parking lot.

Mai Tai

1 ounce dark rum
1 ounce amber rum
½ ounce Curaçao
1 ounce lime juice
1 drop almond extract

Mix ingredients together in a cocktail shaker. Shake and strain into glass with ice. You may also float the dark rum on top instead of mixing it in. Garnish with a slice of pineapple or orange.

TRIPLE A CAFÉ

*I*t survived a fire in 1969, different and indifferent owners, but it could not survive the changing of the times, much to the dismay of its grieving clientele and all the waitresses and kitchen staff who had been around for decades. It served a mostly older blue-collar clientele, and because of the gentrification of the Heights, these people were losing ground to the hipsters moving into the area around the café. When the restaurant opened in 1942, it was adjacent to an open-air market run by the Farmer's Cooperative Marketing Association.

George "Papa" Schmidt opened a café in downtown Houston in 1938, relocating it to Airline Drive in 1942 and calling it Schmidt's "Trucker's Café." The name was changed again in 1969 to "Triple A Café" when it was rebuilt after a fire. George turned over the restaurant to his brother, who later turned it over to his son, Sonny Schmidt, along with his wife, Lucille. Later, Lucille's son, Cecil, ran it along with Sonny. It was one of the best old-timey diners in the city. It served stick-to-the-ribs kind of fare to truckers driving along the nearby two-lane highways for almost seventy-five years. Before the interstate highway system was built, the original Highway 75 to Dallas began on Airline Drive. It was the go-to place for anyone looking for an old-fashioned high-calorie breakfast and comfort food like chicken and dumplings, CFS (chicken-fried steak) and a wonderful lemon meringue pie along with extra TLC dispensed by waitresses sporting big Texas hair. The well-heeled crowds from other parts of Houston joined local Heights

residents standing in line for the famous chicken and dumplings, which was known to regulars as "ambrosia." It was everyone's favorite greasy spoon, with concrete peeking through the well-worn linoleum floor, fake wood paneling and—in its heyday—a jukebox. One mystery, however, that no one ever solved was the height of the bar stools that surrounded the counter. They were very short, and while the counter was also short, no one knows why, not even the Schmidts.

The bread baskets filled with moist rolls and unsweetened corn bread were legendary, as were the Texas toothpicks (deep-fried jalapeno spears) and the fried mushrooms. The CFS was made of exceptionally crisp batter over thin, tender beef slices with a bowl of white cream gravy on the side, and as many times as we ate it over the years, it was never greasy. Also on the side were fries (good) or (better) real mashed potatoes with a rich brown gravy. It should come as no surprise that the CFS was so good that it was often ordered at breakfast with eggs.

Joe Canino Jr. was born in 1922. He opened Canino's Produce Co. in 1958 adjacent to the Triple A Café, which was already firmly established at that time. Joe was the son of an Italian farmer, who grew his produce along Little York Road. In the beginning, the market served mainly Italian and Polish Americans, but by the 1980s, it had become more Latino, serving the Mexican and Central American populations. Joe died in November 2012. His children and son-in-law, Lawrence Pilkinton, who married Joe's daughter, Lyndsay, still operate Canino's Produce Co., the retail operation.

At the time of Triple A's closing, the land on which the restaurant was located was owned by the Canino family. Cecil and Janet Schmidt had owned Triple A from 2001. In 2016, they attempted to re-negotiate their lease, hoping to get a five-year lease with a five-year option. The landowner wanted them to make some renovations to the old place, which they were not willing to do. The Schmidts, who both worked at Berkshire Hathaway, took into consideration the value of the land, the changing times and the demographics of the area and decided that selling was the better option.

One Saturday many years ago, our family was on an early morning outing to the Airline Farmer's Market. Paul was driving on the North Loop, just a tad above the speed limit, and upon being pulled over, he explained to the officer that he had a carload of hungry passengers—his daughter, wife and mother-in-law—all eager to get to the Triple A Café. The officer gave him a knowing nod, a smile and a warning. Paul thanked him and sped off to enjoy his breakfast.

On the day Triple A closed in May 2016, a sign on the door read: "To our friends and loyal customers. We are sad to say we must close AAA. Due to lease negotiations. Thanks for many years of loyalty." There was no warning of its demise. As of today, the entire complex is set to be renovated by MLB Capital Partners. Plans are to improve the traffic flow of cars and shoppers and parking lots and create some green spaces. There will be no way to replace the Triple A Café, however.

VALIAN'S

THE BROWN DERBY (1940s)
GEORGE VALIAN'S CEDAR INN, 2844 N. SHEPHERD DRIVE (1946–?)
VALIAN'S RESTAURANT, 6935 SOUTH MAIN STREET (1955–84)
VALIAN'S REAL PIZZA, 3001 SHEPHERD DRIVE
VALIAN'S REAL PIZZA, CEDAR STREET, BELLAIRE
VALIAN'S REAL PIZZA, 8357 WINKLER AVENUE
VALIAN'S REAL PIZZA FORTY-THIRD STREET AND OAK FOREST DRIVE
VALIAN'S SEVEN VILLAS
VALIAN'S COUNTRY MARKET (1961–65) RICE BOULEVARD AND WEST
ALABAMA STREET
VALIAN'S SPORTS RESTAURANT (1963–?)

George Valian was a renaissance man—at least that's how Patti Ramsey, George's niece, referred to him when we sat down to talk about the family operations. George, born in 1913, in Brantford, Ontario, was the oldest of four siblings, Jack, Albert and Marguerite. George's parents, Michael and Victoria Valian, had left Armenia for England, then moved to Canada before immigrating to the United States, landing in Detroit after World War II. In 1946, George decided to move to Houston because, as Patti tells it, he saw Houston as a city of the future. This is the first of many examples of George's prescience. Albert and Marguerite

moved with him, but Jack remained in Detroit, along with his parents, and opened a very successful restaurant in Dearborn called the Chicago Roadhouse. Meanwhile, George opened the Brown Derby in the 1940s, then later George Valian's Cedar Inn on North Shepherd, before opening what was to become the first of many pizza restaurants, Valian's on South Main. The Cedar Inn was a casual American restaurant that opened around 1946.

The first restaurant to open across the street from the Shamrock Hilton, on the corner of Main and Holcombe, was Nolan's Drive-in. This changed to Lilly's Drive-in and finally to Valian's around 1955. It is hard to imagine today that in the 1950s, pizza was a rarity here. While there is some debate about whether or not Valian's was the first restaurant to offer pizza in Houston—some claim that Doyle's served pizza as early as 1954, and others claim that Simpson's Dining Car also served pizza as early as 1954—there is no question that Valian's made it popular. Later, George operated four Valian's Real Pizza places, where he introduced the concept of fresh takeout pizza. Here you could buy pizza to go and finish baking it at home. The price of thin-crust pre-baked cheese pizza was $1.95, and a deluxe pizza was $2.25. The deluxe was topped with pepperoni sausage, tender mushrooms and green bell peppers. Each pizza was twelve inches in diameter and cut into twelve pieces. Patti told us she still has many of the original pizza dishes from the restaurant. The restaurant attracted more than just lovers of pizza. According to Patti, all of her aunts and uncles and even her mother met their future spouses at the restaurants. Perhaps the answer is in the dough.

At the time, the word *pizza* was always accompanied by the word *pie*. Just think of Dean Martin's song, "That's Amore": "When a moon hits your eye like a big pizza pie." At the entrance to the restaurant there was a sign that read, "A try tells you why you should try pizza pie at Valian's." Valian's also introduced Houston to Pepé Roni, the Pizza Man, who appeared on their menu and advertisements for the restaurant. Pizza was so new to Houston that there is a story that once frozen pizza pie became available in the grocery store, one mother served this new dish to her husband, still frozen, since that's what you did with icebox pie. Because they had to be custom-made at the time, George had his pizza ovens made by the Pappas brothers.

The interior had differently themed rooms like the Cedar Room, full of stuffed deer heads, the Frontier Room, with longhorns on the walls, and the Stein Room with the starry ceiling. There was also the Wedgwood Room, which was a private club area where members could drink. George Valian was a renowned collector of Wedgwood pieces and amassed a sizeable collection. Two black jasper pieces are housed at the Museum of Fine Arts,

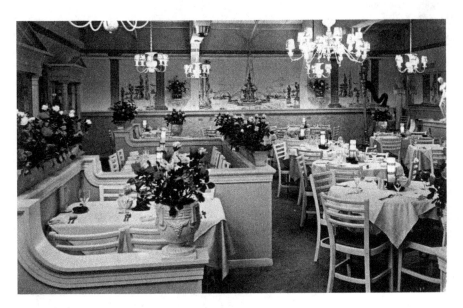

Valian's Restaurant Wedgwood Room. George Valian was a formidable collector of Wedgwood. His collection is housed at the University of Houston Hilton School of Restaurant Management. *Authors' collection.*

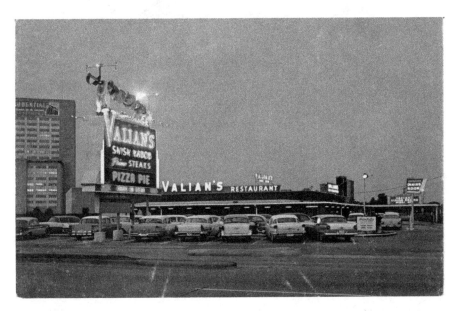

Valian's Restaurant. The back reads, "Shish Kabob—Prime Steaks—Spaghetti—Pit Bar B-Q—Sea Foods—Oyster Bar. Famous for our PIZZA." *Authors' collection.*

Houston Bayou Bend Collection, and the rest of his collection is at the Hilton School at the University of Houston.

While Valian's was noted for its pizza, it also had excellent stuffed shrimp, spaghetti and meatballs with melted cheese and mushrooms, lasagna and, as with many other restaurants of the era, a variety of other food, including steaks, barbecue, hamburgers, shish kabobs, seafood, oysters and fried chicken. The menu also listed a "wop" salad, which was a mixture of many different ingredients dressed with olive oil, vinegar and Parmesan cheese. When Italian immigrants entered the United States, many did not have any papers or documents. They would have the acronym WOP, which stood for "without papers," written on their applications. The term became a pejorative one. Many people remember Valian's as *the* spot to bring a date or go to after a game on a Saturday night or church on Sundays.

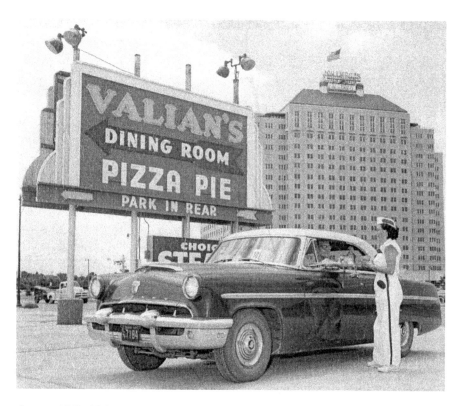

Courtesy of Mike McCorkle, from his book Life and Times around Bellaire.

Courtesy of Mike McCorkle from his book Life and Times around Bellaire.

George Valian at the ribbon cutting at the Main location, 1970s. George was always reinventing, modernizing and staging grand openings for his restaurants. *George Valian Collection, Hospitality Archives, Hilton College, University of Houston.*

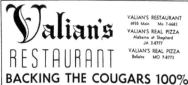

Left: *Houstonian* Student Index, Aaron through Beddoe, 1962. Meet Pepé Roni, the Pizza Man. Houstonian *Yearbook Collection, University of Houston Libraries.*

Below: George Valian at the opening of his Valian Country Market in 1961. *Hospitality Industry Archives, Hilton College, University of Houston.*

156

In the early 1960s, George bought an old A&P store on Rice Boulevard at West Alabama and converted it into one of Houston's first natural food stores. This was no small storefront; it was a large supermarket. In it, he stocked healthy food and vitamins and had a library of books on health. He began baking bread, including heavily seeded breads, and sold it in the store along with natural cosmetics. This is yet another area where George showed he was ahead of the times, although the store did fold after four years due to lack of sales. Around 1963, George opened Valian's Sports Restaurant in a building on South Main that had previously housed one of the Ship Ahoy restaurants. George had all the lighting fixtures custom made for the restaurant to look like one of the balls used in all the popular sports. It also sported an open kitchen and a refrigerated case from which customers could select custom-cut steak.

Many Houstonians still mourn the loss of Valian's because they believe it was the best-tasting pizza they ever had. A brief moment of joy returned for these Houstonians when, in 2008, Luke Raia opened his Raia's Italian Market on Washington Avenue. Luke was a partner in D'Amico's Italian Market Café in Rice Village and a friend of George Valian's. He obtained the recipe for the famous pizza, listed on the menu as "Valien's [*sic*] Deluxe." Raia's closed in 2011, and with it, that famous pizza disappeared. Patti's brother, Mike Puccio, is the only person who retains the original recipe, but he does not plan to re-create it because he believes that the cheeses of today are just not the same as those when Valian's ruled the pizza market in Houston.

Note the large shish kabob skewer on top of the sign. It not only rotated but also spewed flames and was lit up at night and easily seen from far away. Oversized food signs were all the rage in the '50s and '60s.

VARGO'S

(1965–2012)
2401 FONDREN ROAD

For fifty years, Vargo's was a Houston institution, hosting engagement parties, bridal showers, rehearsal dinners, wedding receptions, baby showers, anniversaries, birthdays, prom night dinners, special family dinners, Easter Sunday and Mother's Day champagne brunches, Christmas parties and New Year's Eve celebrations and many a bar or bat mitzvah. Three generations of Houstonians dined there before their senior proms, with close to one thousand students a week during prom season. The idyllic setting—nine acres in a wooded part of west Houston full of azaleas, camellias, draping willows, trees covered in Spanish moss and ivy—became an iconic spot to have your picture taken. Some thought, however, that the charm of the place was more about the romantic settings and surroundings than it was about the food. Vargo's was often awarded the "Best Atmosphere" award from the local media. Taking a stroll through the grounds, you would eventually come to a suspended bridge leading to the gorgeous white gazebo, a place where many a Houstonian tied the knot. At Vargo's peak, there were four weddings a week held there. At night, when the trees were lit by hundreds of lights, it was a magical place. As early as 1974, *Texas Monthly* described Vargo's food as "adequate while the view makes Vargo's a must for visitors to Houston." By the late 1980s, however, it had already started to go downhill. We recall going to Vargo's for Sunday brunch just before it closed.

The gazebo where many a Houstonian tied the knot. *Courtesy of Tim Stanley Photography; copyright Tim Stanley.*

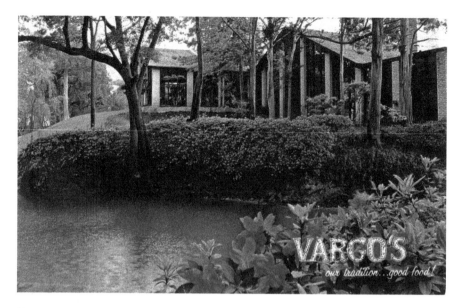

Vargo's postcard. Our Tradition…Good Food. *Authors' collection.*

The piano player seemed as old as the place itself, and everything seemed run down, including the food and most especially the décor.

Vargo's was started by Albert James Vargo, who was born in 1924 in Cleveland, Ohio. After World War II, he entered into his first restaurant venture, running a delicatessen. He moved to Houston in the mid-1950s and owned the first fish and chips franchise here. He later became the *maître d'* at the Shamrock Hilton Hotel, and in 1959, he and his brother, Frank, purchased the Black Angus Steakhouse on Weslayan at West Alabama. Al opened Vargo's in 1965, when Westheimer was but a small two-lane street. He purchased the property from oilman Grover Geiselman's mother, Maude Davis.

In 1991, Vargo's ruffled some legal feathers over peacocks when an Animal Control Bureau (ACB) officer issued a citation to the restaurant for violating the wild animal ordinance, even though the peacocks had lived on the property for over a quarter century. Management was given four days to remove the peacocks. Al hired a lawyer to fight the city, but before the lawyer could let fly with his defense of the peacocks, the case was dismissed because the ACB had apparently misread the ordinance. The peacocks remained and did not have to fly the coop.

Al sold Vargo's in 1996 to Boon Suwanakorte, one of the biggest restaurateurs in Thailand. The first thing Boon did was change the name

of the restaurant to Vargo's International Cuisine, keeping the name mostly intact but adding a slightly new direction. Initial plans called for Suwanakorte to invest $3 million to expand the restaurant and kitchen and renovate the lake and grounds. After the sale to Suwanakorte, Vargo's changed hands many times before being sold to David and Mary Wu of TTC Plaza Ltd., the last owners. Reminiscing about the sale of the property, Al told Maxine Messenger at the *Houston Chronicle* that his first dinner party there was for Maude Davis, and his last was the wedding reception for his friend Vic Damone's daughter, Daniella. Al Vargo died in 2008 at the age of eighty-four.

On the property, there was a private lake called Lake Vargo, which had been there for more than 125 years. Some believe this was previously called Sam Houston Artesian Springs because it may have been where Sam Houston camped for three days while planning the Battle of San Jacinto. The grounds were full of wildlife, with twenty or more peacocks, ducks, geese, flamingos and swans. The lake was full of bass and turtles. At its peak, Vargo's employed three full-time groundskeepers and a feed person just to care for the animals. The multilevel restaurant had the appearance of a Swiss chalet. The cocktail lounge and terrace were busy, separate from the restaurant itself. There was a quieter club room with a fireplace as well as a private dining/party room. The large main dining room could seat 350 and was painted in cool blue and green colors, matching the plumage of the peacocks, and offered superb views of the lake and grounds. Almost every evening, there was a piano player who enhanced the romantic feeling.

Vargo's served continental cuisine with an emphasis on seafood, beef and chicken. A complimentary appetizer platter was served that consisted of breads, cheese spread, fruit, vegetables and cold beef and chicken. Classic dishes such as lobster bisque, *escargots bourguinonne*, fresh rainbow trout *meunière*, seafood crêpes, chicken Cordon Bleu, chicken Florentine, Gulf shrimp Henri (stuffed with lump crabmeat), red snapper *Livornese* or Pontchartrain, roast Long Island duckling *à l'orange*, double Frenched lamb chops, shrimp scampi and veal *scallopini al Marsala* were some of the many items available. Some entrées were served family style. Almost every main dish was served with green beans, and two employees spent most of their time snapping and preparing them for the lunch and dinner service. Their most famous dessert was a chocolate roll, added to the menu early on by a baker who worked in President Roosevelt's White House.

In October 2011, TTC Plaza Ltd. filed for Chapter 11 bankruptcy protection, converted in April 2012 to Chapter 7 liquidation. David and

Mary Wu had been operating on a lease basis since January 2012, and as of May 2012, they owed $150,000 in back rent to TTC Plaza Ltd., the company which they owned. So, in essence they owed the money to themselves. The bankruptcy court turned the property over to a trustee. It was taken over by Hunington Properties. By May 2013, the restaurant was in the process of being torn down. It was to be replaced by Vargo's on the Lake, a development of apartments and townhouses. The property was so large that 261 apartments and 13 townhouses were built on the property. It opened in August 2014. Houston developer Sandy Aron paid $6.1 million for it.

There were a couple of years when the new owners neglected the twenty or so peacocks that were on the property. By April 2013, the local newspapers were reporting that the peacocks were no longer being fed. While they are perfectly capable of caring for themselves, they had become accustomed to being fed and were flying over the chain-link fence that surrounded the property, looking for food. Some people were dropping bags of food over the fence to try to feed them. Hunington Properties tried to get the Houston Zoo to take them, but it was not interested. A recent call we made to the management of Vargo's on the Lake property revealed that there were fourteen peacocks still roaming the property and thriving. They are still an important part of the history of this area.

Vargo's Cheese Spread

½ pound butter
1 ½ pounds cream cheese
2 tablespoons finely chopped fresh chives
1 tablespoon paprika
salt and pepper to taste
2–4 ice cubes

Blend all ingredients in a blender except ice cubes. Add ice cubes once other ingredients are blended. Blend until smooth. Refrigerate 45 minutes before serving.

YE OLD COLLEGE INN

(1920–1978)
6545 MAIN STREET

When it opened in 1920, what we call Rice University today was the William M. Rice Institute for the Advancement of Literature, Science and Art. In 1960, the name was changed to William Marsh Rice University. In 1918, across from the main entrance to the Institute, George Martin started a small refreshment pavilion called the Owl, named after the school's mascot. It was so popular with Rice students that it was hard to make them leave. One reviewer said this: "The boys would always shoot craps in his place until George in desperation turned out the lights to try and make them leave." In 1920, he built Ye Old College Inn opposite Rice Field. It was popular with Rice coaches but also attracted a broader, sophisticated clientele. It became a hub for everything related to Rice football and a refuge for Rice students mourning a loss or a party room when they celebrated a victory.

The restaurant was on the ground level, and George Martin lived upstairs. The design of the building, with its arches and tiled roof, was similar to other buildings on the Rice campus. This similarity should come as no surprise, as it was designed by William Ward Watkin, who designed many of the buildings on the Rice campus. It would not be too farfetched to assume the similarity was done deliberately to get people thinking that the restaurant was an extension of the campus. In 1924, Martin expanded the restaurant by adding the Spanish Room.

In a scrapbook of clippings he called his book of memories and left to Rice University, Martin tells us that he was "a devotee of sports and athletics." Newspaper articles in the scrapbook let us know that he was also an excellent golfer, scoring three holes-in-one over his golfing career. But most of all, he was an avid Rice football fan and had "seen every Rice team in history play in virtually every game." He was fondly known as "Mr. Owl." Martin loved football so much that in 1925 he started the George Martin Award, to be given to the best Rice football player; it was awarded each year until 1960.

The scrapbook also contains a critical review of the restaurant in 1921 by an unknown reviewer. The review is remarkable in a number of ways. Houston was much smaller when this review was written because the reviewer tells us that the restaurant is "out at the end of Main Street." This place was considered beyond the city limits. The reviewer also says that here, "One is served a meal rather than just food," suggesting that the food was of high quality. Talking about the service, the writer commented, "The service is deft—grinning, colored waiters all white clad." Today, this phrase stops us in our tracks, but those were different times, and photos from the era show the servers were African American men all wearing white jackets.

In 1946, Martin sold Ye Old College Inn to Ernest Coker. In 1961, Coker sold it to Houstonian George John Lewis, who ran it until the late 1970s. In the 1950s, consistent with the college theme, Coker added a Varsity Room, which was used as a banquet hall and for dances. Ye Old College Inn was demolished in 1978 to make way for the St. Luke's Medical Tower.

The menu was continental but leaned heavily toward meat, a whole page being devoted to it, a section titled "Dining in the Grand Manner." Crab and oysters were served in many different ways. The menu also let patrons know that the seafood was local: "The finest of local seafoods are obtained fresh daily from nearby bays and the Gulf of Mexico." French dishes like escargot and *noisette de boeuf* also made an appearance. Ye Old College Inn was famous for a number of items: Flame-Kissed Charcoal Broiled Steaks, baked potatoes, oysters Ernie, Ernie's fudge pie and angels on horseback, which are bacon-wrapped oysters. The origin of this last dish goes back to Victorian England, although the associations with angels and oysters and horseback and bacon do not appear to have any meaning. An early menu declared, "We are the originators of the rubbed, tubbed, scrubbed Idaho potatoes." Each potato was served with a tiny flag that read, "You may eat my jacket. We have been rubbed, scrubbed

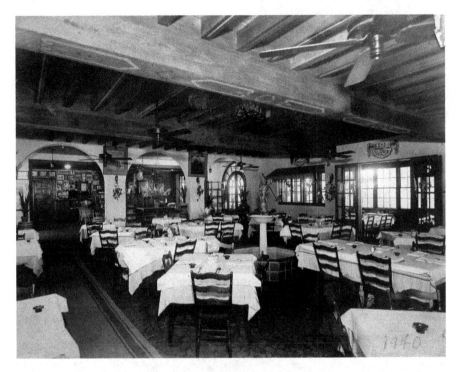

The interior of Ye Old College Inn. The back reads, "Houston's most famous Dining Place has international reputation for the excellence of its Steak and big baked Potatoes. Select your own Steak and brand it yourself the way you want it Charcoal Broiled. 'R' for Rare. 'M' for Medium, Etc. Established in 1919." *Authors' collection.*

and tubbed." Customers had to be educated that it was acceptable to eat the potato skin or jacket. The potatoes were topped with "cheese, chives, bacon chips and sour cream." Some dishes were flambéed at the table. Obviously, the dishes served here were too expensive for impoverished students, but other Houstonians flocked to Ye Old College Inn, which was one of the first and few upscale restaurants in the city. In the 1950s, Ye Old College Inn received accolades as one of the twenty greatest restaurants of the world. On a 1959 menu celebrating forty years in business, a sticker read, "Houston's Oldest Fine Restaurant."

The baked potatoes served at the Old College Inn were also famous for another reason. In an article he wrote for the *Houston Chronicle* on September 5, 2005, Leon Hale tells us about an interview he had in the early 1950s with a farmer who raised hogs: "The farmer said he was making a living off the women who went to dinner at that restaurant and ate only half the baked potatoes that came with their steaks. He was fattening his hogs on leftover

potatoes soaked in all that butter. He was also doing pretty well selling the silverware he found in the garbage."

Chef Herman A. Walker (1906–2002) was the restaurant's chef from somewhere around 1948 until it closed. He created many of the recipes served here. At one time, oysters Ernie were oysters Herman and shrimp Ernie called shrimp Herman. In 1967, the *Milwaukee Sentinel* published a recipe for Herman's Many-Prized Fudge Pie, which is identical to the recipe for Ernie's fudge pie, except for the addition of one tablespoon of instant coffee and some cinnamon and allspice.

In the recipe booklet titled 'Some pages from the recipe collection of Ernest Coker," excerpted below, we learn just how popular shrimp Ernie was: "In Duncan Hines' cook-book—'Baking, Broiling and Barbecueing'—shrimp Ernie is listed as one of his 12 all-time favorite recipes." In "Readers Remember the Tasty Creations from Ernest Coker," Ann Criswell remarked, "Restaurants treasured a rating by Duncan Hines, whose recommendations were a guarantee of quality even into the 1960s." Hines, a traveling salesman, developed a list of restaurants he visited and

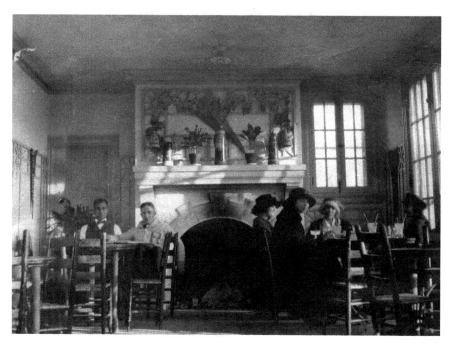

"Ye Old College Inn Dining Room 1920." *Rice University: http://hdl.handle.net/1911/21900.*

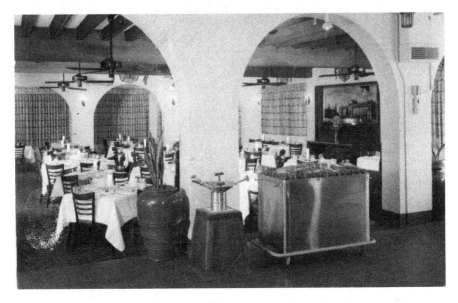

Another postcard featuring the interior of Ye Old College Inn. *Authors' collection.*

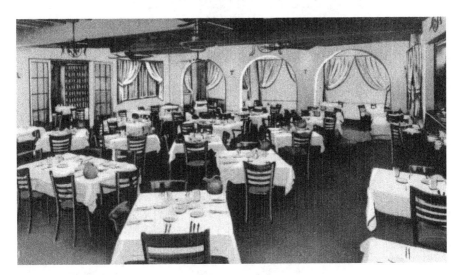

Main dining room. Ye Old College Inn, Houston, Texas—Est. 1919. *Courtesy of the Trustees of the Boston Public Library.*

OYSTERS ERNIE

Salt and pepper 24 selected oysters - dredge in flour - grill on lightly
buttered griddle on top of the stove until crisp and browned on both
sides. Do not broil in oven. If no griddle is available, use a heavy
skillet on top of the stove. Sprinkle oysters with butter or cooking
oil while grilling. Do this on both sides -- it browns and crisps them.

Place the following ingredients in a sauce pan over a low fire and heat
thoroughly, but do not allow to come to a boil:

 2 Tbsp. melted butter
 1/4 cup fresh lemon juice
 1 cup A-1 Steak Sauce
 2 Tbsp. Lea & Perrin's Worcestershire Sauce
 2 jiggers Sherry or Madeira wine

Blend 2 Tbsp. flour into 3 Tbsp. water and stir in as thickening after
sauce is heated. Correct sauce seasoning to taste -- by addition of A-1
sauce if too thin, or Sherry if too thick and highly seasoned.

Place freshly grilled oysters on a hot serving plate and dress with the
heated sauce. Insert frilled toothpicks in oysters. This sauce can be
saved, strained, re-heated, and used again.

SHRIMP ERNIE*

Prepare 2 lbs. raw jumbo shrimp as for frying (de-vein and remove tails
and shells) -- marinate 1 or 2 hours in refrigerator in the following
sauce:

 1 pt. Wesson Oil 4 Tbsp. catsup
 1 level Tbsp. salt 1 tsp. paprika
 1 small pod garlic (chopped fine)

Put shrimp on sides in shallow pan -- pour over some of sauce -- do not
let sauce cover them. Broil under flame until lightly browned on both
sides -- 3 to 5 minutes on each side at 350° or medium flame. Serve on
a hot plate on frilled toothpicks.

* In Duncan Hines' cook-book -- "Baking, Broiling and Barbecueing" --
 Shrimp Ernie is listed as one of his 12 all time favorite recipes.

ERNIE'S FUDGE PIE

In top of double boiler or over low heat, melt:
 1/2 cup (1 stick) butter
 3 squares unsweetened baking chocolate.

Meanwhile, place in mixing bowl and beat until light:
 4 eggs.

Beat into the eggs:
 3 Tbsp. white Karo syrup
 1½ cups sugar
 1/4 tsp. salt
 1 tsp. vanilla
Now, add the chocolate mixture (slightly cooled). Mix thoroughly and
pour into a 9-inch pastry-lined pie pan.

Bake at 350° for 25 to 30 minutes, or until top is crusty and filling is
set but still somewhat soft inside. Do not over-bake. Pie should shake
like custard so it will not be too stiff when cool.

This may be served plain, but is best served with a topping of a thin
spade of vanilla ice cream.

HOLIDAY PIE

 (Mincemeat and pumpkin, both, come in layers in this pie.)

To fill one 9-inch pie, mix together:
 1/2 pound packaged Non-Such mincemeat
 1/4 pound tart apples (diced finely with skins)
 3 Tablespoons sherry wine or brandy

Combine in a separate bowl:
 1 cup sugar
 2 eggs (beaten)
 2 cups canned pumpkin
 1/2 teaspoon salt
 1 teaspoon cinnamon
 1 teaspoon allspice
 1/4 teaspoon ginger
 1 cup milk
 1½ teaspoons melted butter
Place the mincemeat mixture in the bottom of an unbaked 9-inch pie shell.
Then pour the pumpkin on top. Bake at 350° for 45 minutes, or until firm.

Above and opposite: Some pages from the recipe collection of Ernest Coker, 1960. *Rice University: http://hdl.handle.net/1911/26744.*

Rice Football coaches Cecil Grigg, Harold Stockbridge and Jess Neely (*left to right*) standing behind the Coaches' Table, 1956. *Rice University: http://hdl.handle.net/1911/70823.*

first published *Adventures in Good Eating* in 1935. The first Michelin Guide was published in 1900.

One fascinating piece of memorabilia of Ye Old College Inn remains with us to this day: the Coaches' Table was started in 1921 by Tommy Thornhill, one of the restaurant's managers. In the Owl Club of Rice Stadium is a heavy wooden table into which are burned the autographs of many a famous athlete and coach. The signatures of Bear Bryant, John Heisman, Darrell Royal, Jim Thorpe, Duffy Doherty, Homer Norton, Dana X. Bible, Jess Neely, Weldon Humble, Dicky Maegle, Bill Henry, Fred Hansen and many others all appear on the table. Whenever famous coaches and athletes visited the restaurant, which happened frequently, they were handed a burnishing tool and expected to sign their names. The table was originally in the restaurant's loft and was lost for many years before turning up again in 1990.

YOUNGBLOOD'S FRIED CHICKEN

(1945–69)
5604 BISSONNET
6441 MAIN STREET

*J*ulius Harper "Pap" Youngblood started out as a cotton farmer in Speegleville, Texas, just west of Waco. In 1930, a year after the Great Depression started, he bought five hundred baby chicks, raising them as a side business to make ends meet. He and his sons, Weldon and Ovid, started Youngblood's Fried Chicken on Franklin Avenue in Waco in 1945. It was an immediate hit with Waconians, who lined up outside the door waiting to be served. Their second restaurant opened in Dallas a year later on Zang at Colorado and was the largest and busiest in the chain. They expanded quickly after to fourteen locations by 1961. By 1967, Youngblood's had thirty locations, plus an additional six franchises, in Fort Worth, San Antonio, Houston, Austin, Port Arthur and Beaumont. There was also a restaurant called Youngblood's Old Mill Inn at the state park where the Texas State Fair took place every year. However, it was so busy during the fair that they operated it only as a takeout restaurant. The Youngbloods also had fifty poultry farms, a feed mill and a processing plant all around the state. In addition, they sold frozen chickens as well as a dry packet of their batter mix to grocery stores all across Texas. Youngblood's became a Texas institution, and many people today remember it as "the best fried chicken they ever tasted." Brothers Weldon and Ovid parted ways in

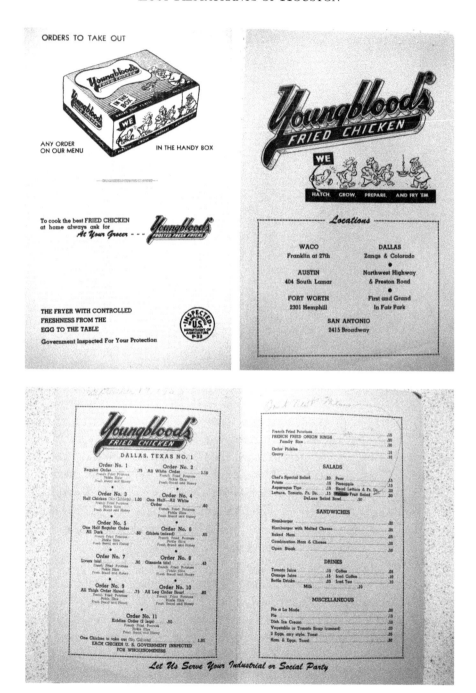

This page: Youngblood's menu. *Courtesy of Nancy Youngblood Counts; photo by Paul Galvani.*

1959–60, and Ovid took over the operations. In 1968, the company announced plans to expand nationwide. However, increased competition from other fried chicken restaurants, a series of financial mistakes and insurmountable debt proved to be too much, and the company abruptly shut down all the restaurants in 1969.

The most popular item on the menu was the No. 2—an All White Order with French fried potatoes, a pickle slice, fresh bread and honey for $1.10. Note the hand-written annotation on the menu that says "omit next menus." Nancy Youngblood Counts explained to us that this is how her father made changes to the menus before the next printing. He would also use the same method to change prices. Along with the fried chicken, Youngblood's also served yeast rolls that came in a basket covered with a cloth to keep them warm. Butter and honey were in jars on every table for the rolls, but some people put honey on their chicken. Nancy also told me that the honey had to be Burleson's, since that was "always the best." The chicken also came with pickle slices.

The Youngblood's slogan was "We hatch, grow, prepare and fry 'em." An advertisement from the period talks about the Youngblood's "farm-to-table" approach to raising chickens before it became a popular concept again:

Photo of a food fair promoting Youngblood's Fried Chicken Batter mix. *Courtesy of Nancy Youngblood Counts.*

"We start with the hen that lays the egg…New Hampshire White Leghorn chicks.…65,000 of these special crosses are hatched every week."

It was through this quality control that Youngblood's was able to deliver consistently great-tasting chicken. Nancy Youngblood Counts, the granddaughter of Harper Youngblood and the daughter of Weldon Youngblood, now lives in De Soto, a suburb of Dallas. We visited her to photograph some of the memorabilia she kept from the restaurants. One story she related was how when she and her family visited her parents' house, they would be given lots of chicken breasts to take home. Nancy commented that these were very large, plump breasts that were too large to be served in the restaurants, since they would take too long to cook properly and likely might have been tough.

Left: Youngblood's dinnerware. *Photo by Paul Galvani.*

Below: The dinnerware used at the restaurants was distinctive and has become a collector's item. Here, Nancy Youngblood Counts displays it in her home. *Photo by Paul Galvani.*

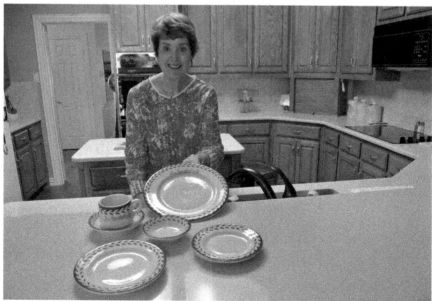

Even though the Youngblood family ceased to be involved after 1970, the restaurants continued operating for a number of years. The recipe for the fried chicken is much talked about, and many believe they know the ingredients, including some former employees. Common belief is that the wet batter contained powdered milk and whey. However, an advertisement for the restaurant disputes that, saying that it did not use any premade powdered mixes, only whole milk and buttermilk. We asked Nancy about the powdered whey, and by the look she gave us, it was clear that she had never heard of the use of this ingredient. We then asked if she still had the recipe and would share it with us for the book. That's when she told us it was published in the cookbook of her local church, the Cliff Temple Baptist Church. She dug out a copy and allowed us to publish it here. Each year, for many years, Nancy prepared the original Youngblood's Fried Chicken recipe for 250 parishioners as a fundraiser. She was careful to let us know that she prepared seven hundred pieces of chicken.

In May 2017, a team of Austin-based restaurateurs led by Chef Todd Duplechan, working with a member of the Youngblood family, revived the Youngblood's Fried Chicken chain in Austin at 1905 Aldrich Street in the Aldrich Shopping district at Mueller.

In 1945, when the restaurant opened, the concept of carrying out your fried chicken meal was new. The company issued a brochure titled "Fried Chicken to Take with You" in order to explain the concept. The brochure also gave suggestions on when to use the carryout feature: "For a quick

Photo by Paul Galvani.

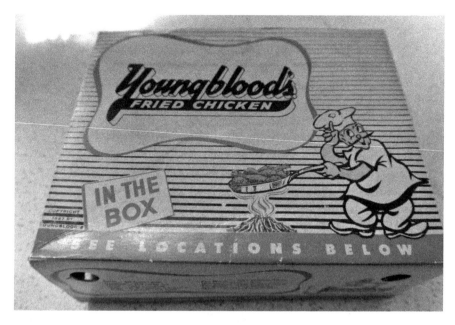

To the best of our knowledge, this is the only Youngblood's Fried Chicken carryout box still around. *Courtesy of Nancy Youngblood Counts; photo by Paul Galvani.*

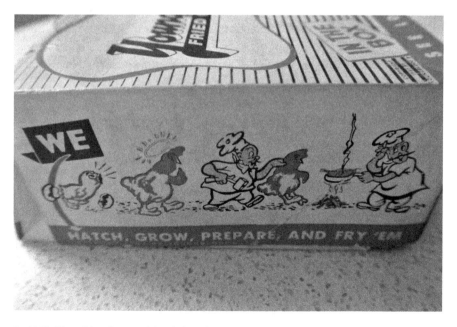

In 1947, Youngblood's copyrighted the takeout box. *Photo by Paul Galvani.*

meal at home, unexpected guests or a splendid lunch for traveling, try a box of Youngblood's Fried Chicken." The carryout box was remarkable for two reasons. It had vent holes to keep the fried chicken crispy and was lined with cellophane to prevent the grease from seeping through by weakening the cardboard.

In his spare time, Weldon Youngblood was an inventor who held a number of patents. One such patent was for his YCO Reel. It was a device that makes it easier to roll up cables, hoses, wires, ropes and so on. He also developed deep-fat fryers with special heat sources to cook fried chicken long before there were such commercial machines available, as well as a towing bracket for cars. In his later years, he turned his creative talents to making beautiful pieces of stained glass.

Youngblood's Fried Chicken Batter

¼ cup salt
1 cup milk
1 cup buttermilk
Flour

Dissolve salt in milks. Dip chicken in milks, then in flour.

BIBLIOGRAPHY

Abbott, Rona, and Ann Criswell. *Dining in Houston*. Seattle, WA: Peanut Butter Publishing, 1978.

Acosta, Teresa Paloma, and Ruthe Weingarten. *Las Tejanas: 300 Years of History*. Austin: University of Texas Press, 2003.

Bell, Mary Joe, and Betty Edge. *Confederate House Restaurant Cookbook*. Houston, TX: Hutchins House Publishing, 1996.

Chapman, Betty Trapp. *Historic Photos of Houston*. Nashville, TN: Turner Publishing, 2006.

Cole, Thomas R. *No Color Is My Kind: The Life of Eldrewey Stearns and the Integration of Houston*. Austin: University of Texas Press, 1977.

Criswell, Ann. *Houston Gourmet Cooks 2*. Houston, TX: Houston Gourmet Publisher, 1988.

Federation of Italian-American Organizations of Greater Houston. *Houstonians of Italian Descent: Their Culture and Heritage*. Houston, TX: Cate Media, 2003.

Harwell, Debbie. "Sonny Look: A Humble Showman." *Houston History Magazine* (March 2012).

Houghton, Dorothy Knox Howe, et al. *Houston's Forgotten Heritage*. College Station: Texas A&M University Press, 2014.

Johnston, Marguerite. *Houston: The Unknown City 1836–1946*. College Station: Texas A&M University Press, 1991.

Kelley, Kitty. *His Way: The Unauthorized Biography of Frank Sinatra*. New York: Random House, 1983.

Krenek, Thomas, H. *A History of Houston's Hispanic Community*. College Station: Texas A&M University Press, 2012.

———. *Mexican American Odyssey*. College Station: Texas A&M University Press, 2001.

Leftwich, David. "The History of Houston Food." *Sugar & Rice* (November 2016).

———. "Peeling Back the History of 1902 Franklin." *My Table* (Spring 2017).

Lent, Joy. *Houston's Heritage Using Antique Postcards*. Houston, TX: D.H. White, 1983.

Martin, William C. "Preparing the Fatted Calf." *Texas Monthly* (February 1974).

McComb, David G. *Houston—A History*. Austin: University of Texas Press, 1981.

McCorkle, J. Michael. *Life and Times around Bellaire, Texas*. Houston, TX: self-published, 1986.

Meyer, Lasker M. *Foley's*. Charleston, SC: Arcadia Publishing, 2011.

Monsanto, Daniel E. *Houston*. Charleston, SC: Arcadia Publishing, 2009.

Moore, Hank. *Houston Legends*. New York: Morgan James Publishing, 2015.

BIBLIOGRAPHY

Morrison & Fourney's General Directory of the City of Houston. Houston, TX: 1884.

Pen and Sunlight Sketches of Greater Houston: The Most Progressive Metropolis in the South. Houston, TX, 1913.

Polk, R.L. & Company. *Houston City Directory*. Houston, TX, 1866.

Powell, William Dylan. *Lost Houston*. London: Pavilion Books, 2016.

Roggen, Ted. *Press Releases*. Lincoln, NE: Writers Club Press, 2001.

Rudine, Ken. "Houston, the 2nd Hundred Years." *Texas Escapes*, March 6, 2012.

Saxena, Jaya. *The Book of Lost Recipes*. Salem, MA: Page Street Publishing, 2016.

Sloan, Anne. *Houston Heights*. Charleston, SC: Arcadia Publishing, 2016.

Texas State Historical Association. *The Handbook of Texas Online*. https://tshaonline.org/handbook.

Von der Mehden, Fred, and Edward C.M. Chen. *Chinese in Houston*. Houston, TX: Houston Center for the Humanities, 1982.

Walsh, Robb. *Texas Eats. The New Lone Star Heritage Cookbook*. Berkeley, CA: Ten Speed Press, 2012.

———. *The Tex-Mex Cookbook*. Berkeley, CA: Ten Speed Press, 2004.

Weil, Russell. "More Restaurant Memories." *The Buzz*, December 1, 2016.

———. "Restaurant Memories." *The Buzz*, November 1, 2014.

Whitaker, Jan. "Ship-themed Restaurants." *Restaurant-ing Through History*, October 9, 2013.

INDEX

ABOUT THE AUTHORS

PAUL GALVANI was born in London into an Italian family, the many branches of which were all in the restaurant business. He grew up with and was involved in all aspects of the business. He owes his love of food to his mother and father, both of whom were great cooks. After graduating from Queen Mary College in London with his BA in modern languages, he moved to Houston in 1978. In 1980, he graduated with his MBA in marketing from the University of Houston. After graduating, he spent five years in the oil field services industry, but the food biz beckoned. In 1984, he went to work for Riviana Foods Inc., the largest marketers of rice and pasta in the United States, where he heads up the marketing department.

Paul became an adjunct professor of the Marketing Department of the Bauer School of Business at the University of Houston, where he still teaches today. He began writing about food and restaurants in 1997 for the *Houston Press* and subsequently for the *Paper City* magazine as well as *Fort Bend Lifestyles* magazine, the *Houston Chronicle, Edible Houston, Houstonia* magazine and *Culture Map*. Paul is the author of *Houston's Top 100 Food Trucks*, published in 2014.

An intrepid foodie, there is nothing Paul enjoys more than discovering a hole-in-the-wall place that serves remarkable food. He lives in Sugar Land, Texas, with his wife, Christiane, and daughter, Jacqueline.

CHRISTIANE GALVANI, born in Kiel, Germany, is a professional translator, a court-licensed interpreter for the State of Texas and an adjunct professor at Houston Community College with over thirty years of experience of

teaching English to foreign students. As a result of becoming acquainted with students from around the world and her childhood as an "Exxon brat," living and traveling throughout the world, she learned to appreciate the cuisines and cultures of various countries.

When she was in her early twenties, she had the good fortune to marry into a loving Italian family with a restaurant background. As a consequence, she and her husband, Paul, not only enjoy cooking at their home—where they test new recipes out on each other and ultimately on their friends—but also love going out to restaurants all over the Houston area.

When not teaching, translating or cooking, Christiane likes to go visiting hospital patients with her therapy dog, Sophie, a champion counter surfer and unauthorized taster in her own right.

Visit us at
www.historypress.com

Printed in the USA
CPSIA information can be obtained
at www.ICGtesting.com
LVHW020233240124
769826LV00004B/53